HELLO, DEAR FRIEND! WE KNOW HOW DIVERSE OUR WORLD OF PLANTS AND ANIMALS IS. IN THIS BOOK, WE INVITE YOU TO VISUALLY EXPLORE VARIOUS DOG BREEDS, TAKE PENCILS AND MARKERS IN HAND, AND ENJOY THE PROCESS!

FROM LABRADORS TO CHIHUAHUAS, FROM POODLES TO BOXERS – HERE YOU CAN GET ACQUAINTED WITH A VARIETY OF BREEDS KNOWN FOR THEIR CHARACTER, APPEARANCE, AND UNIQUE CHARM.

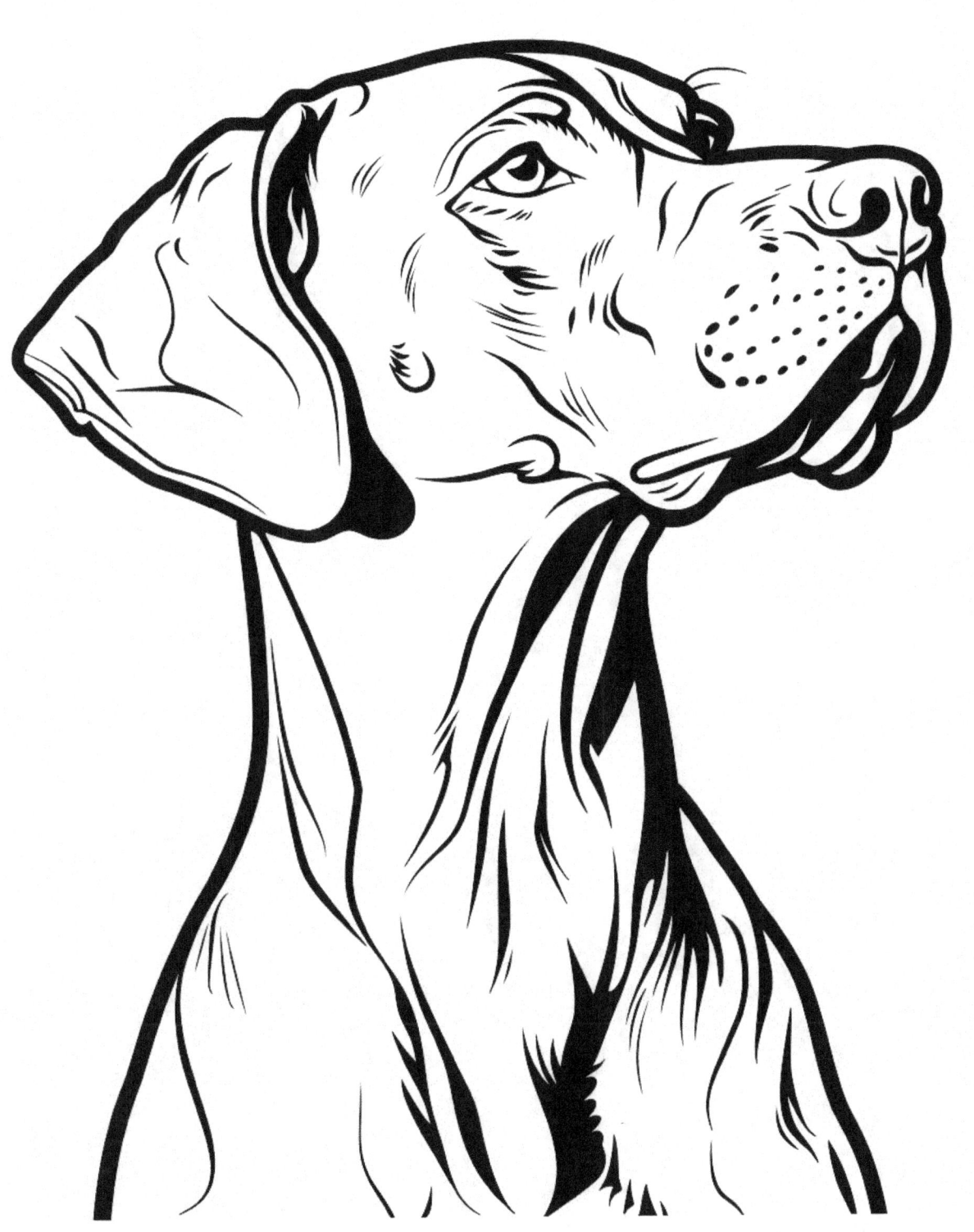

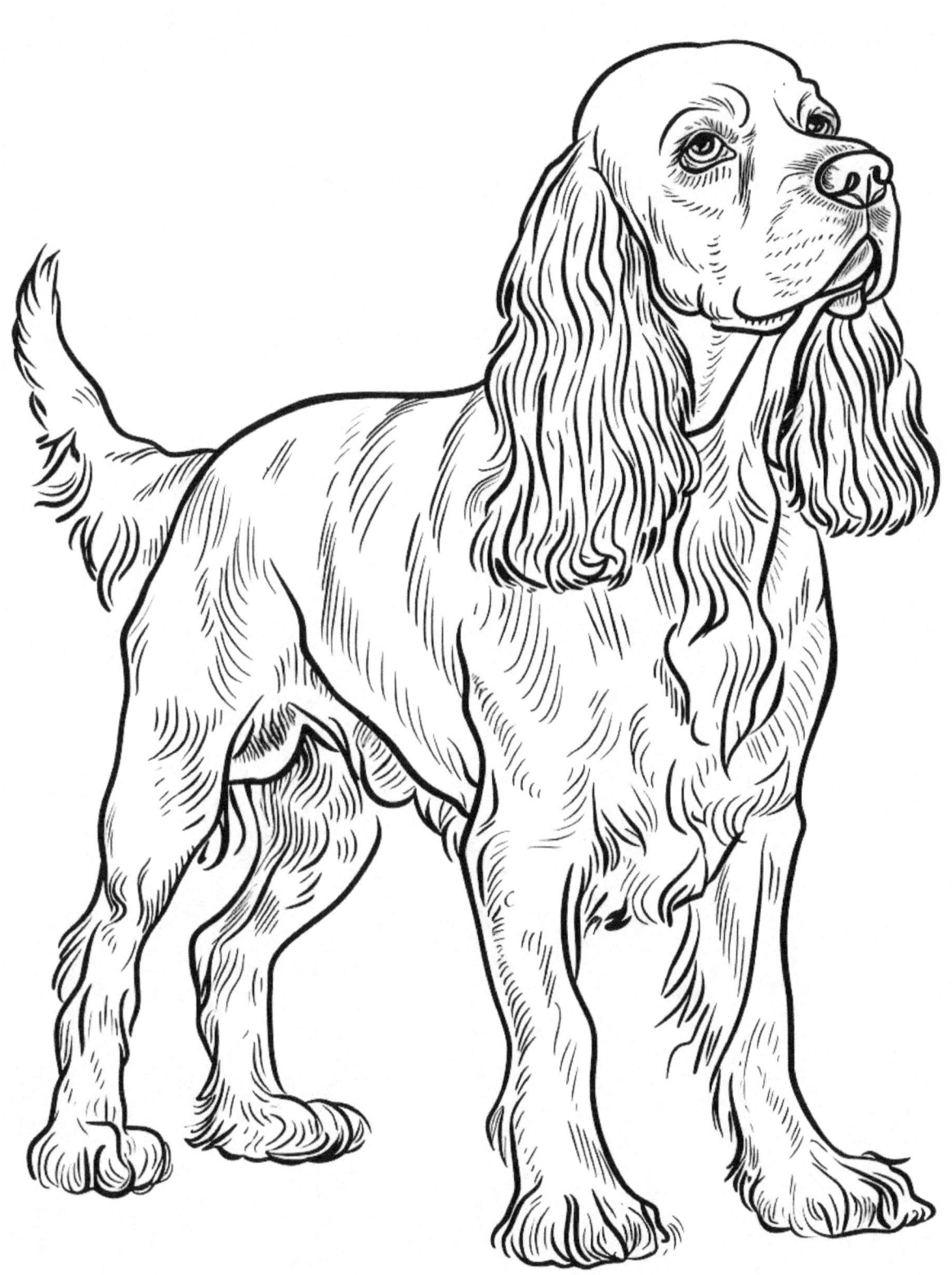

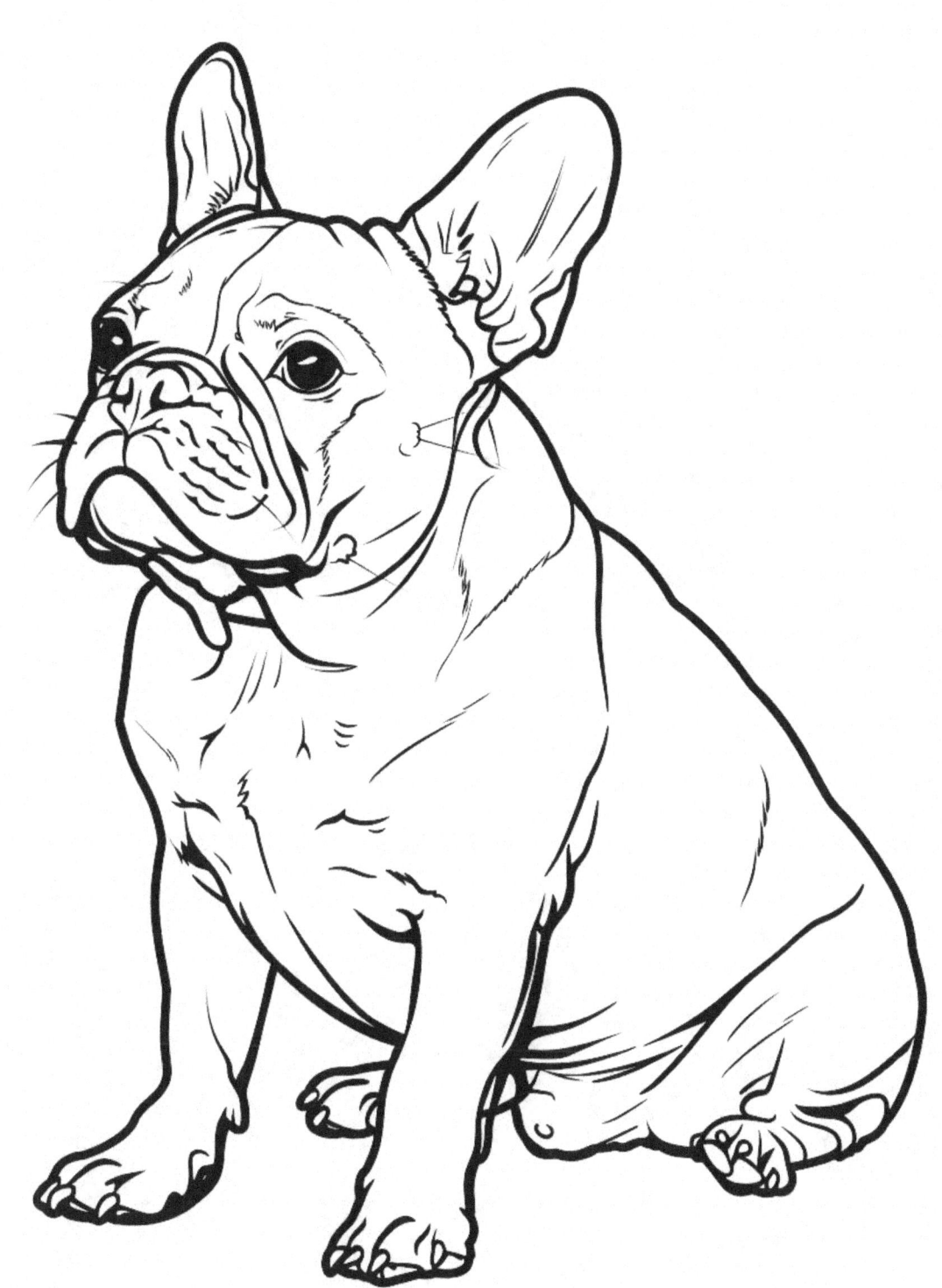

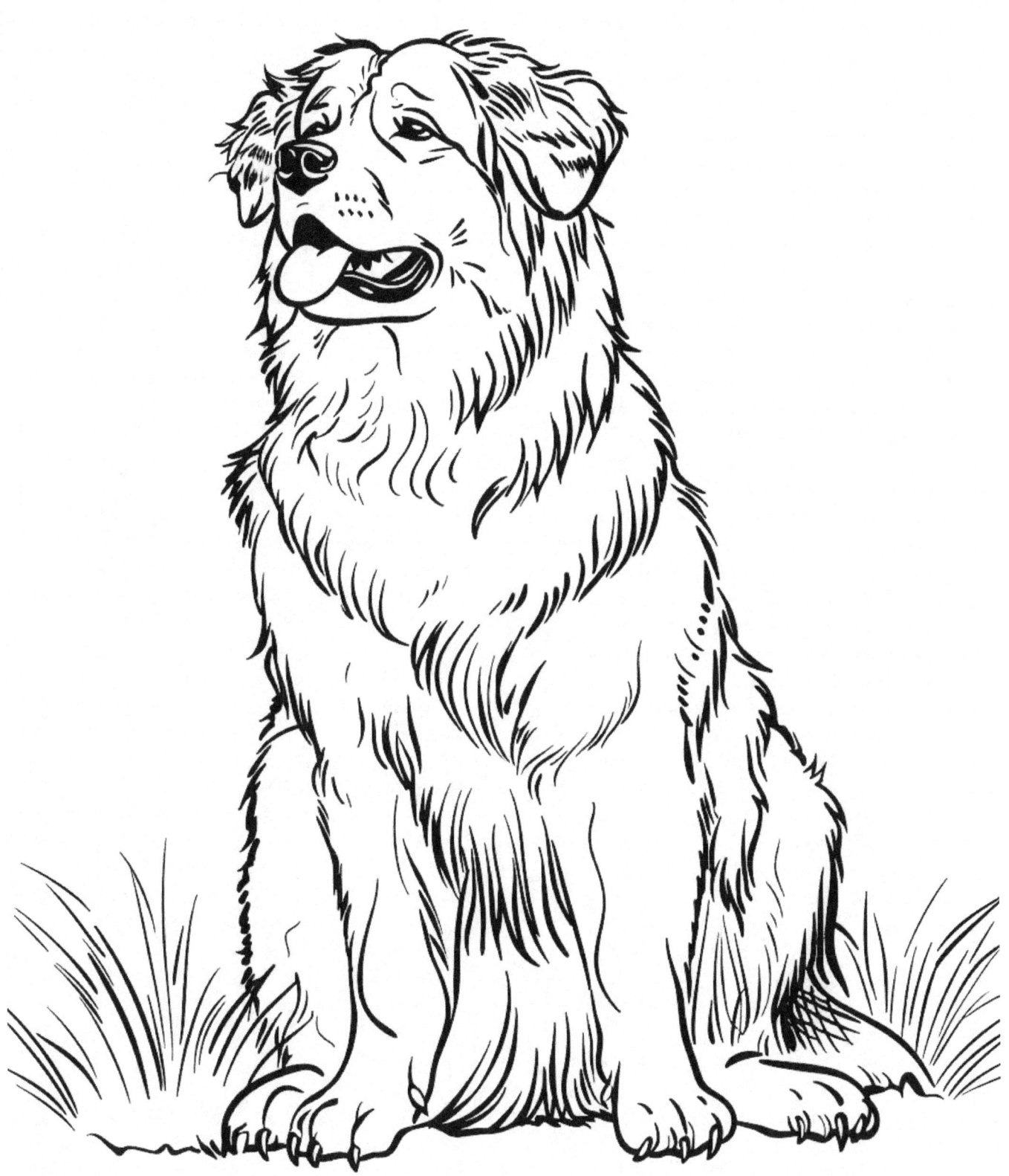

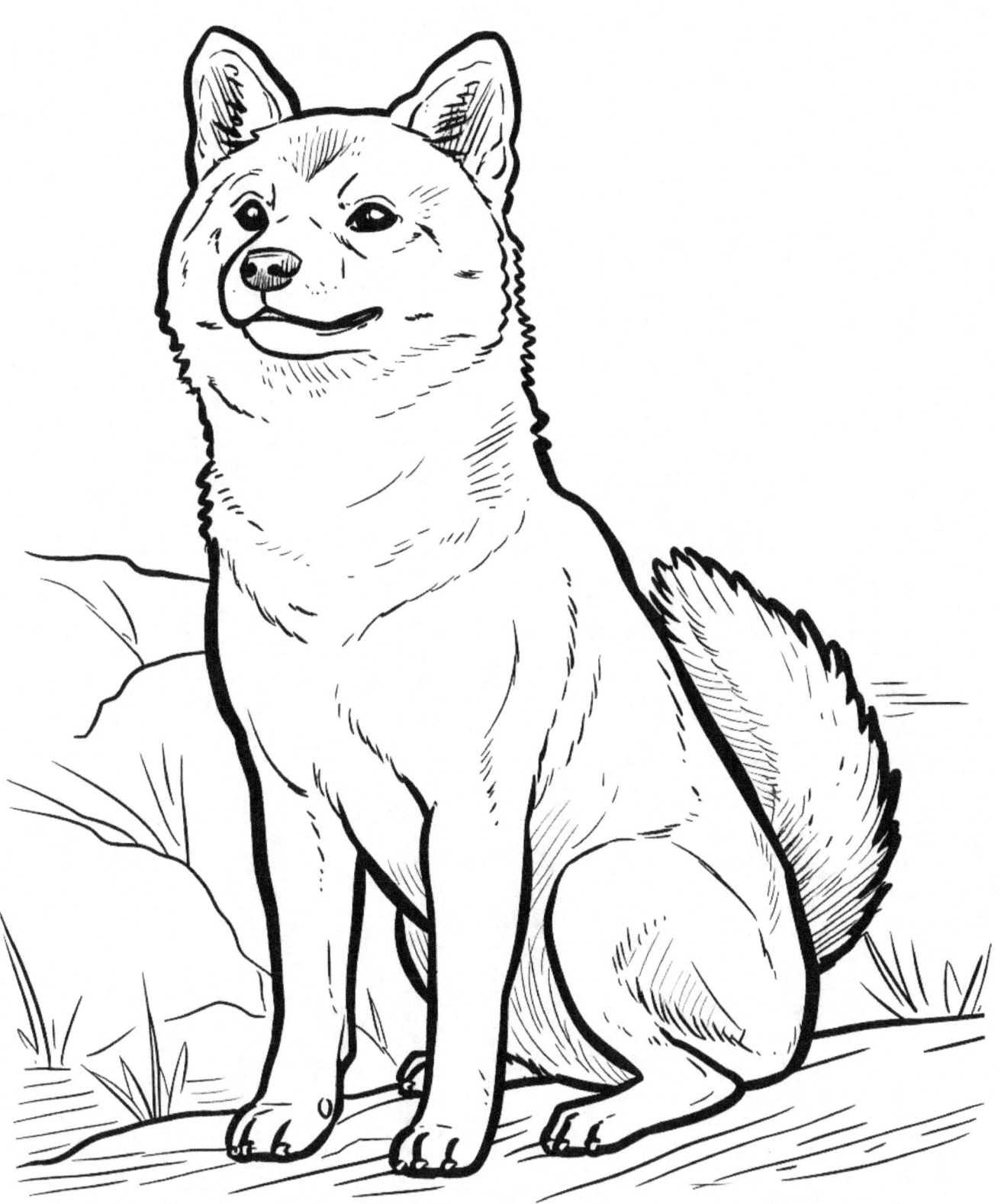

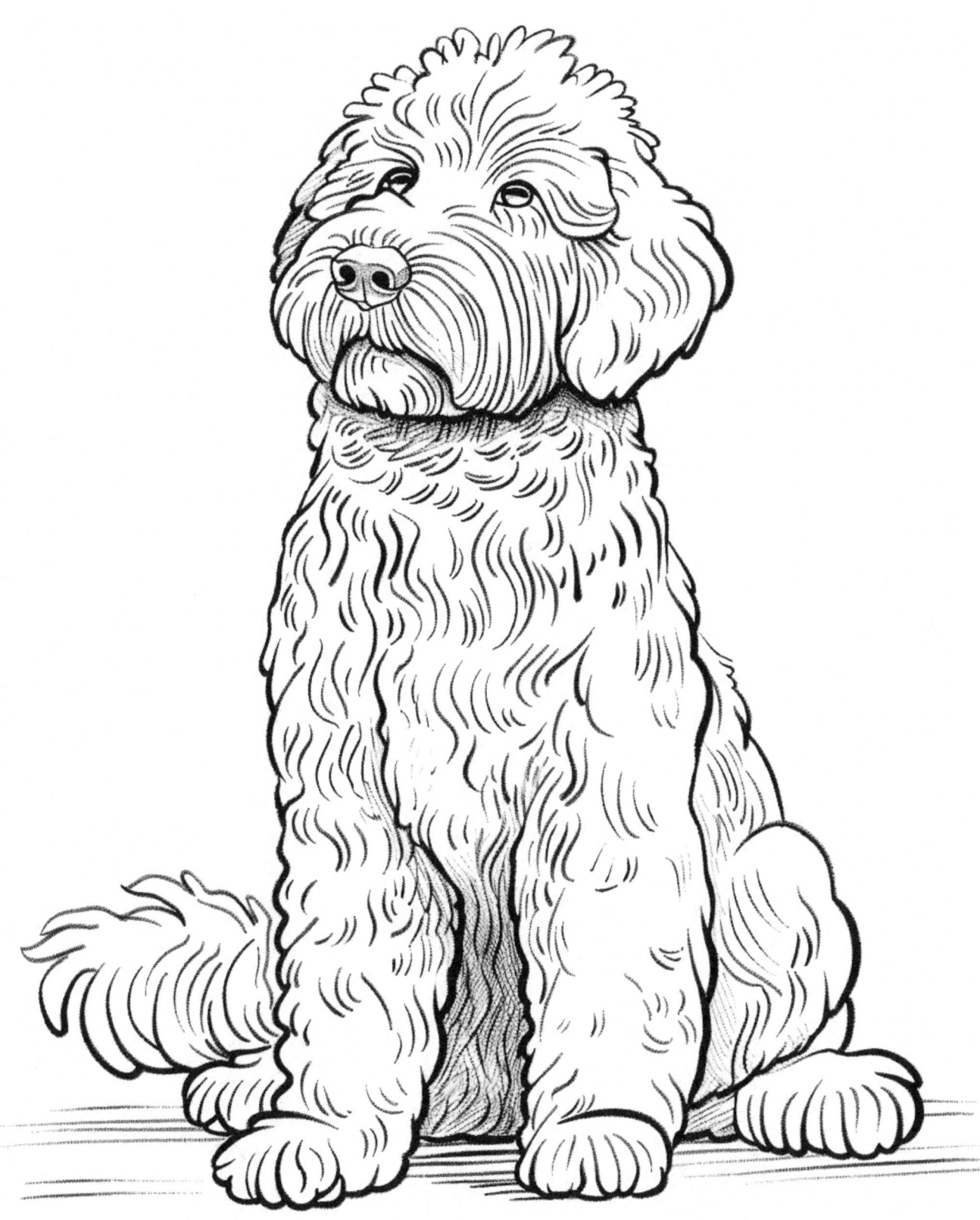

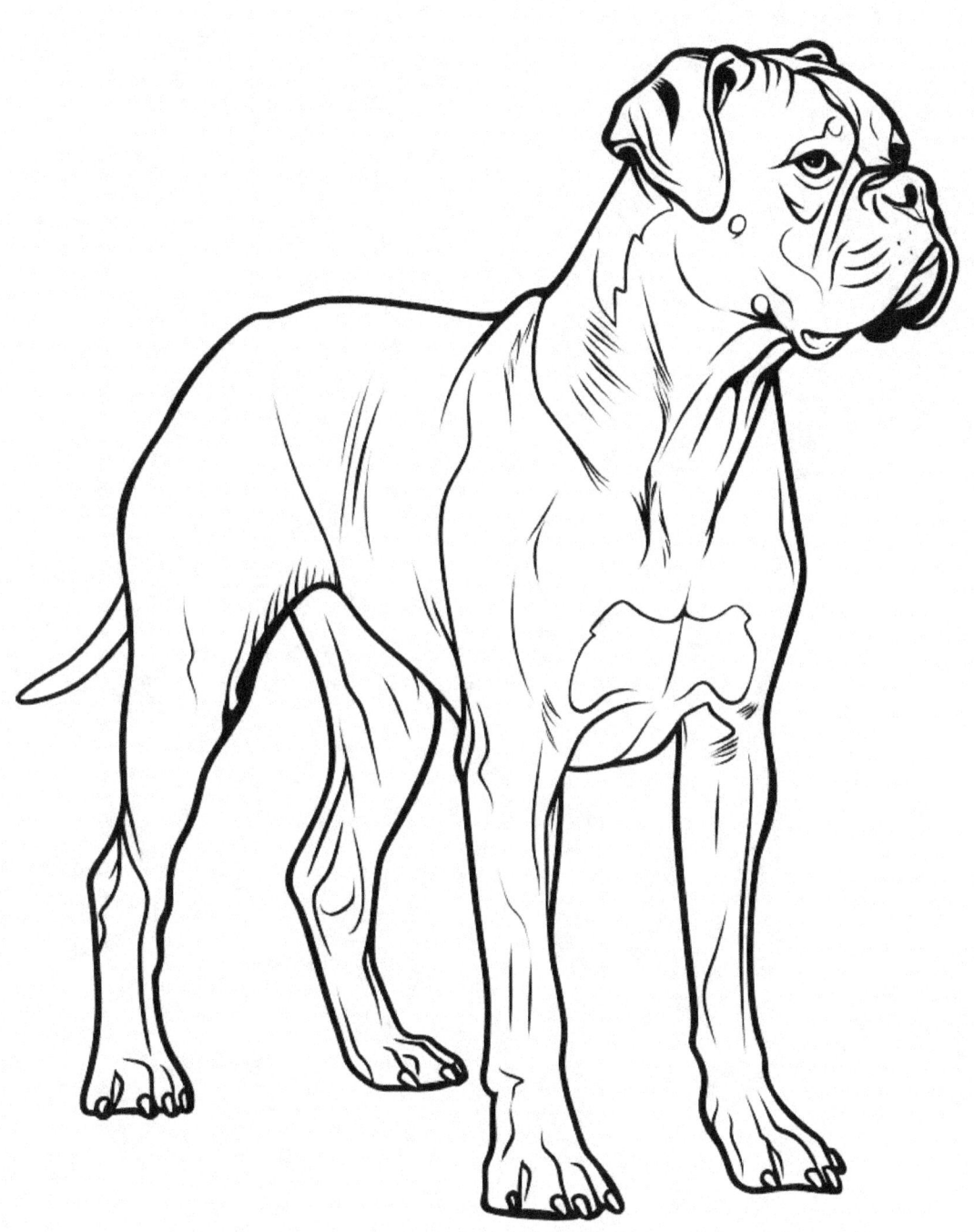

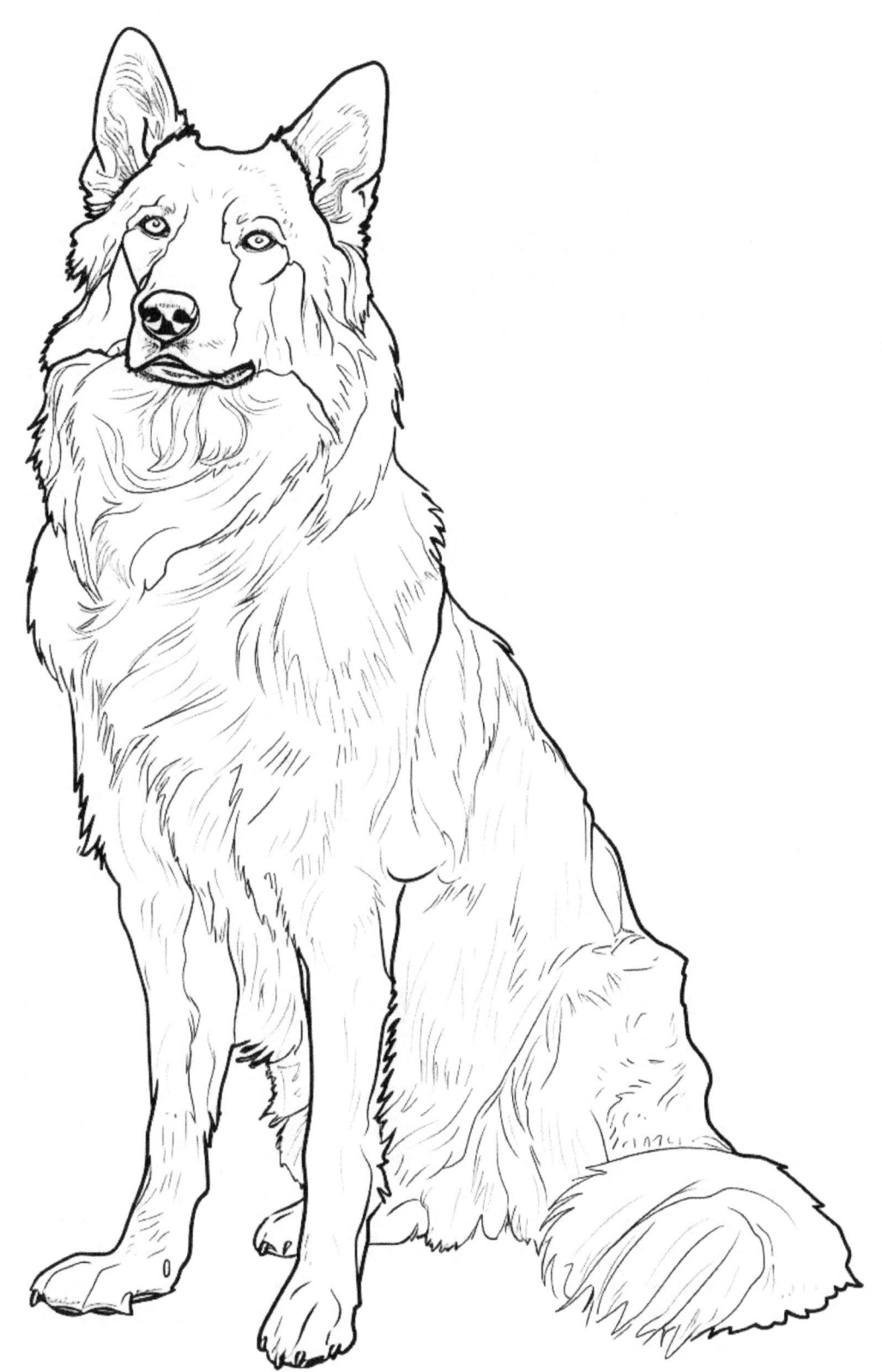

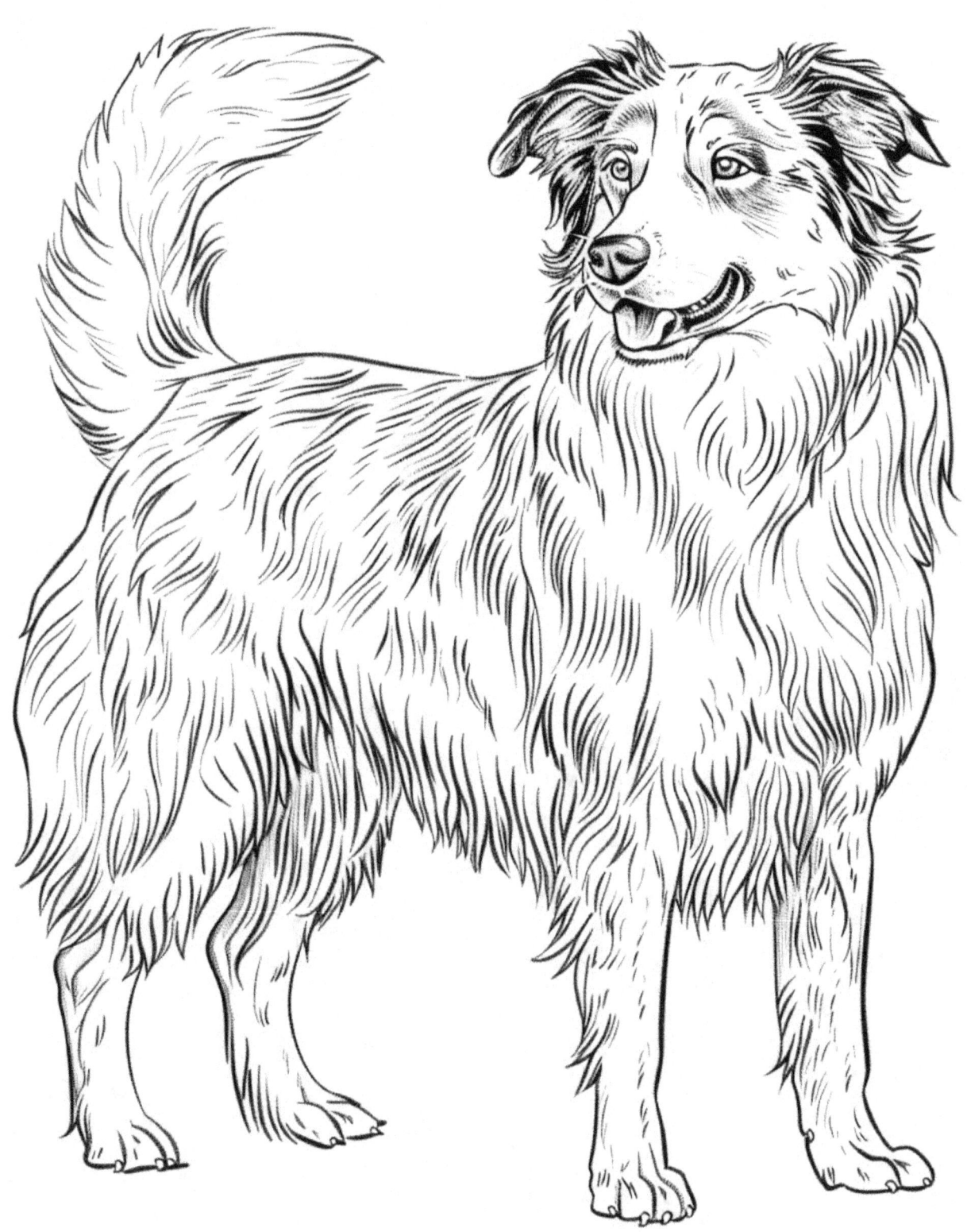

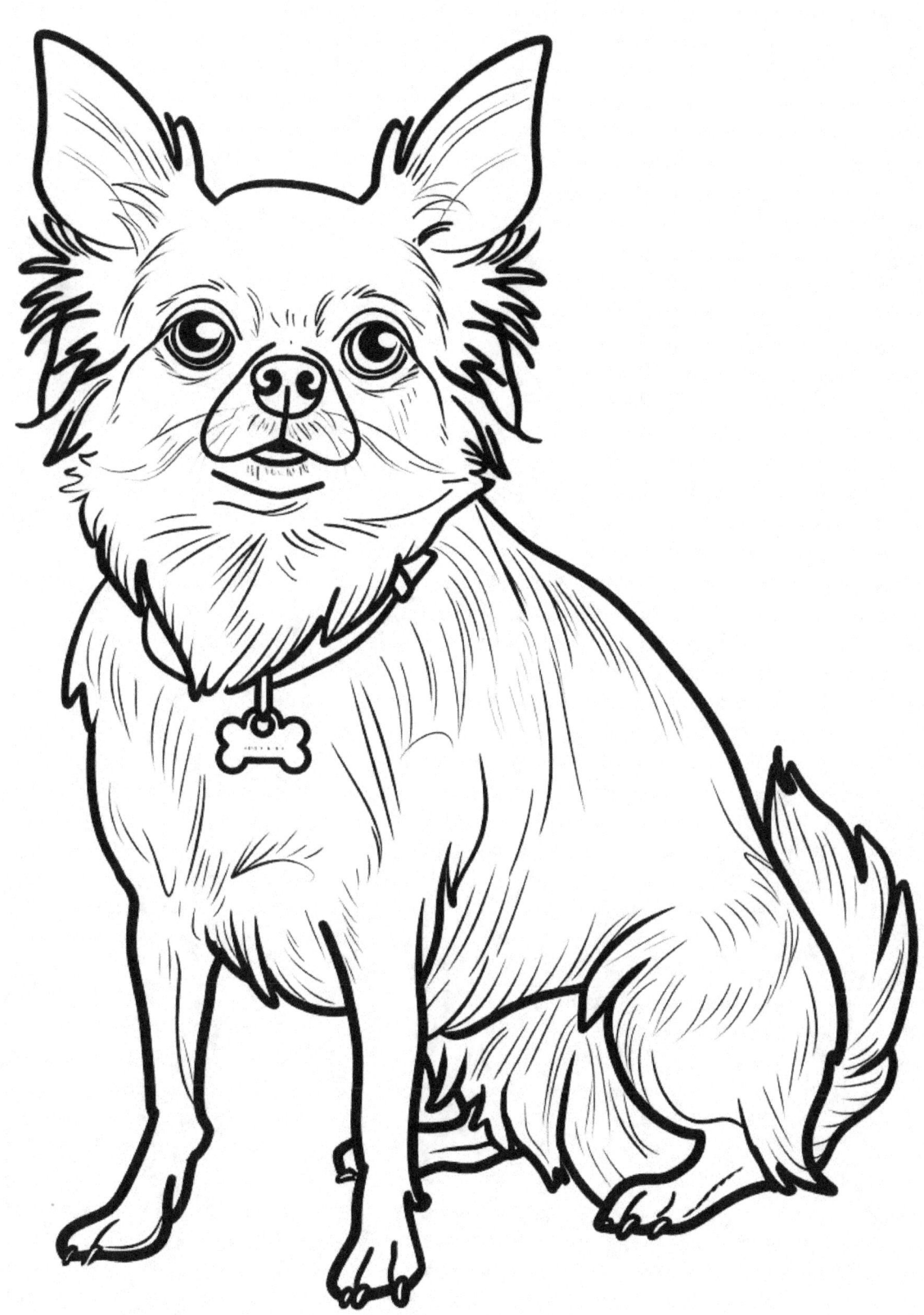

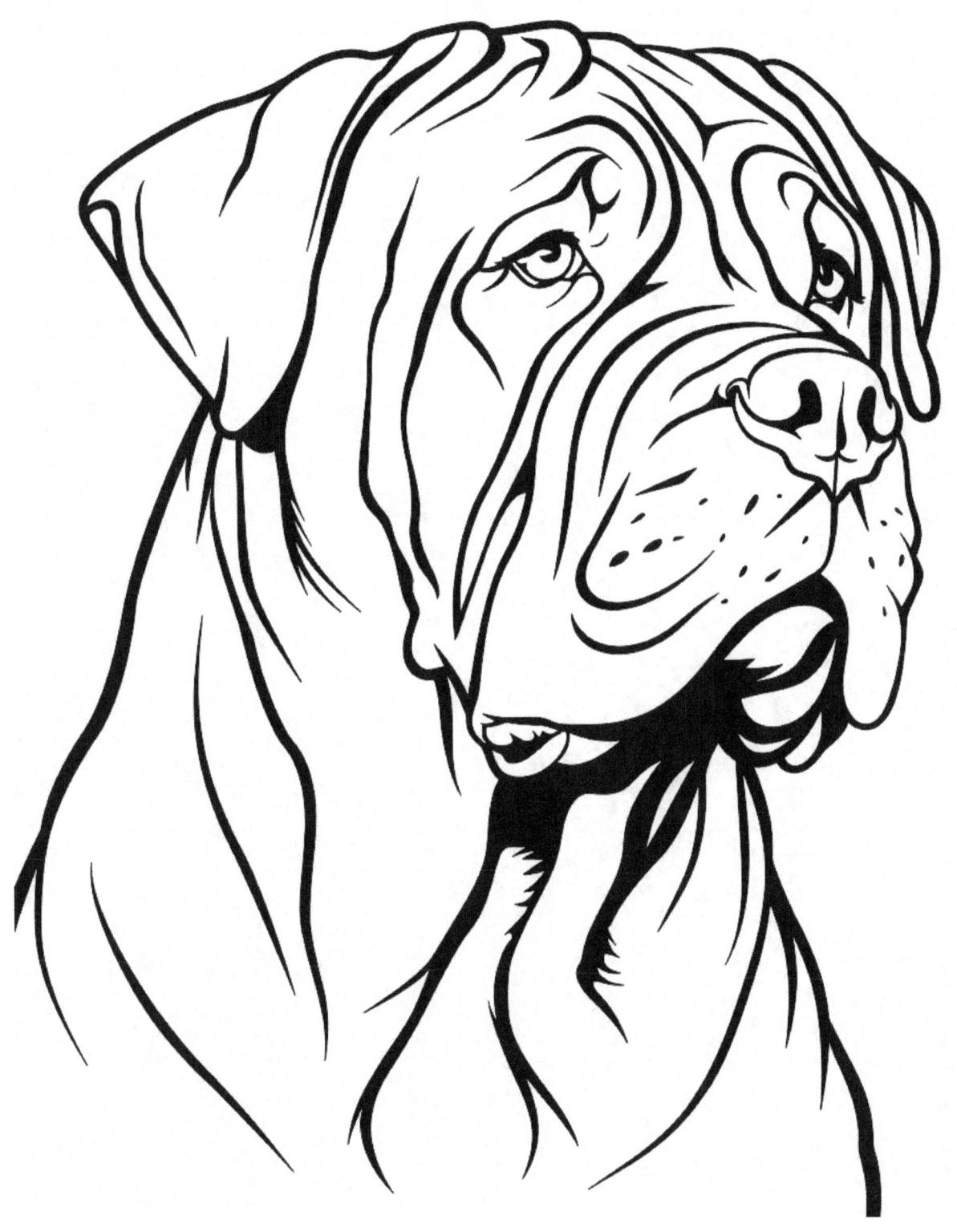

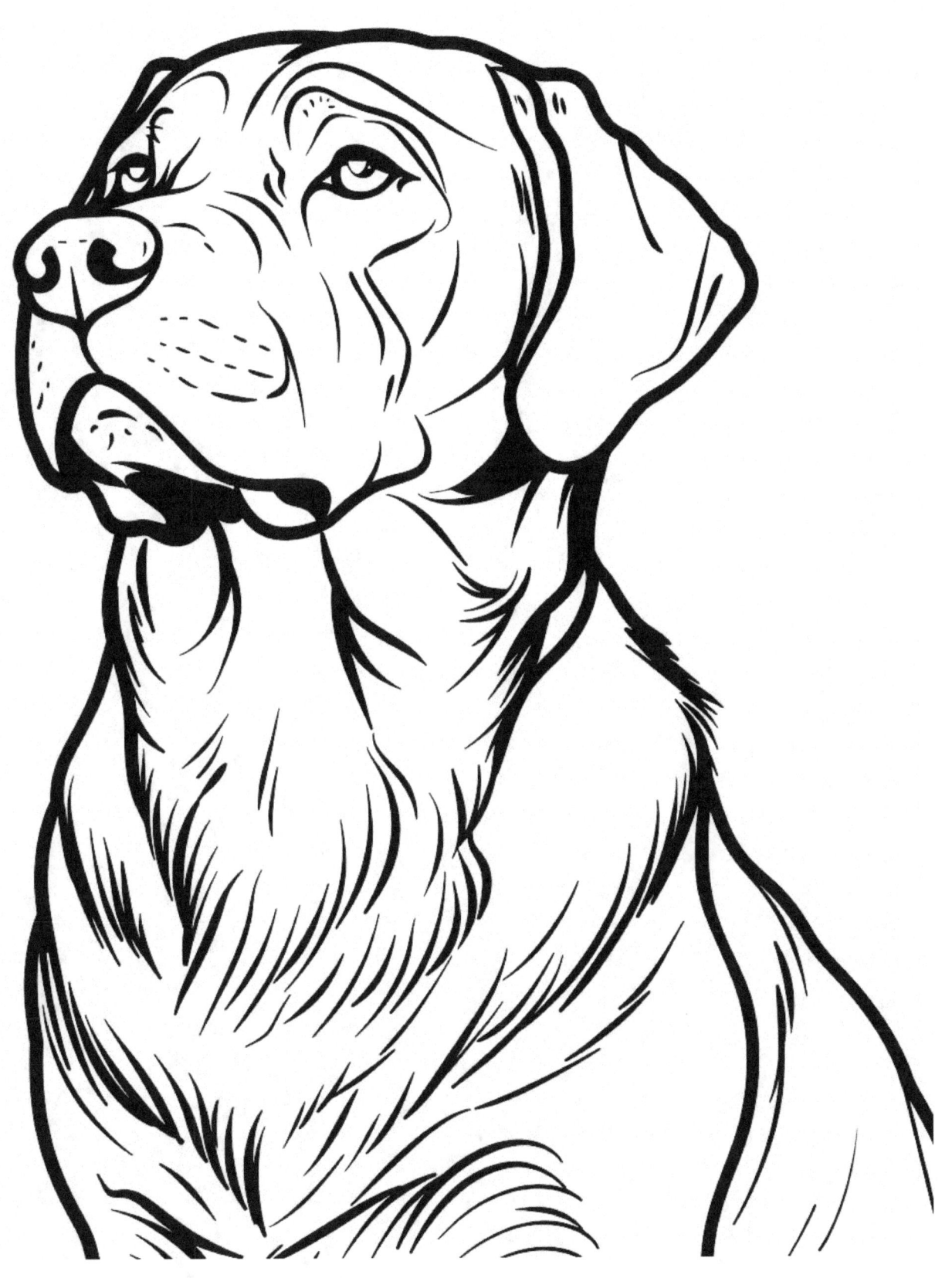

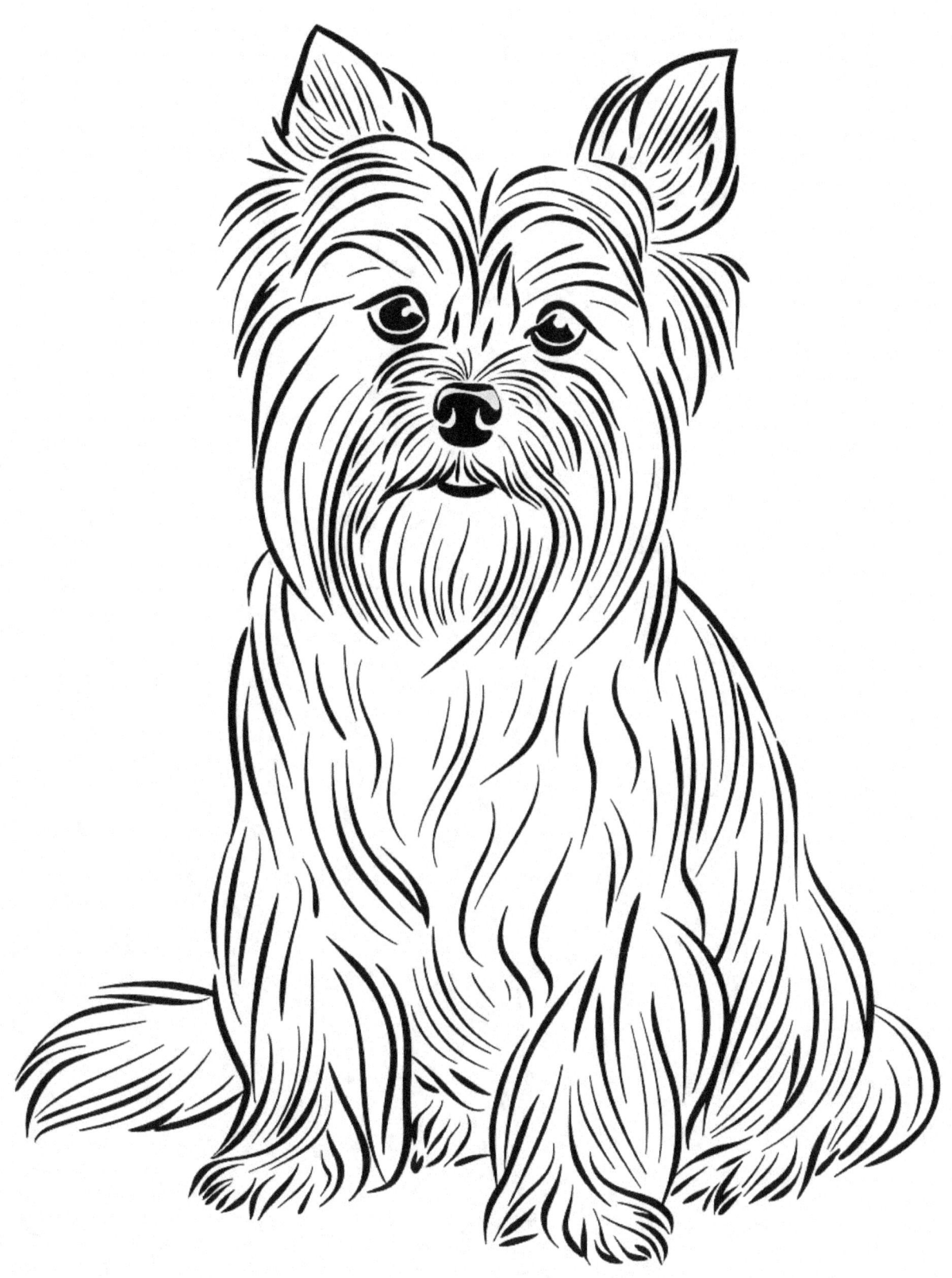

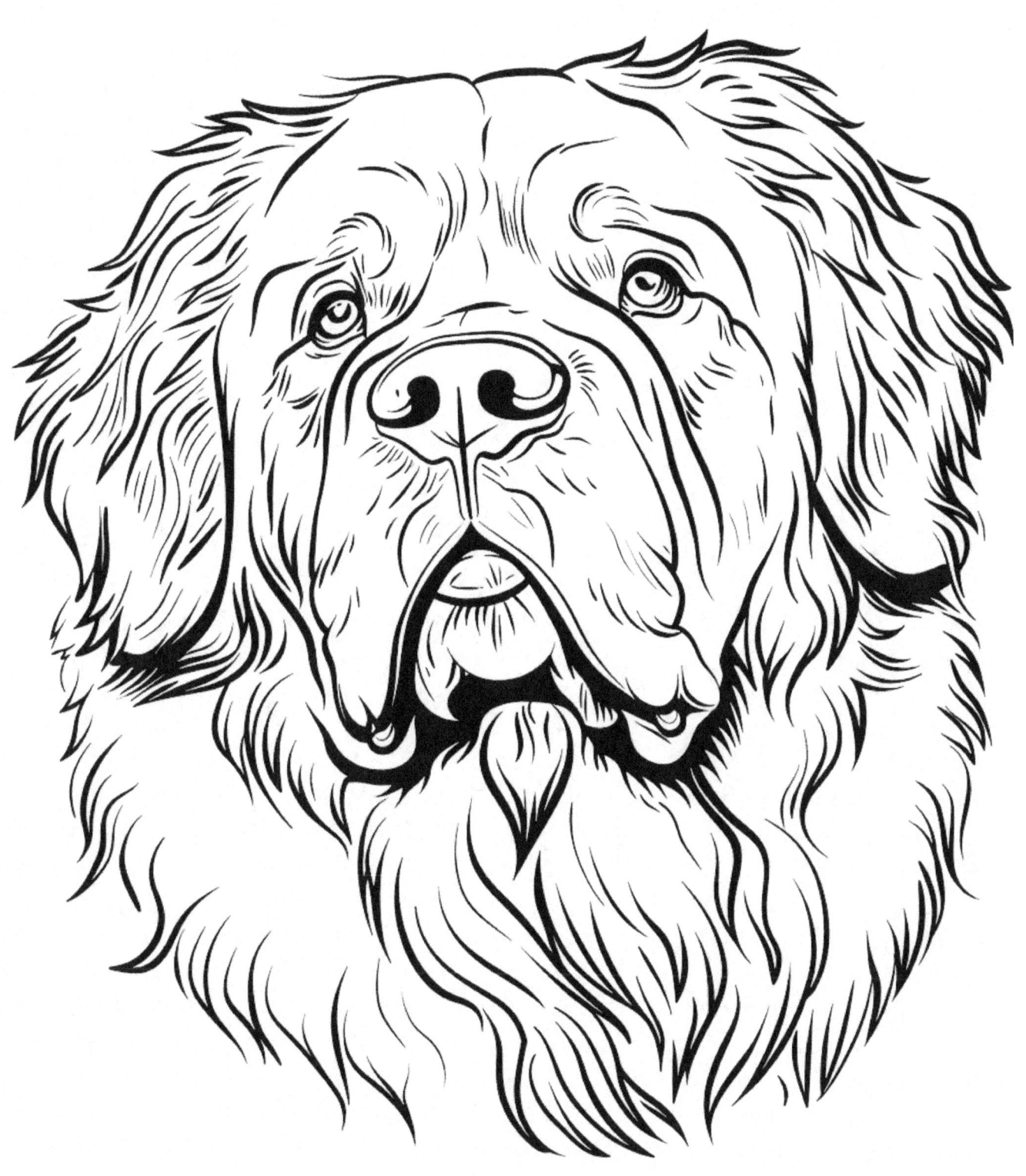

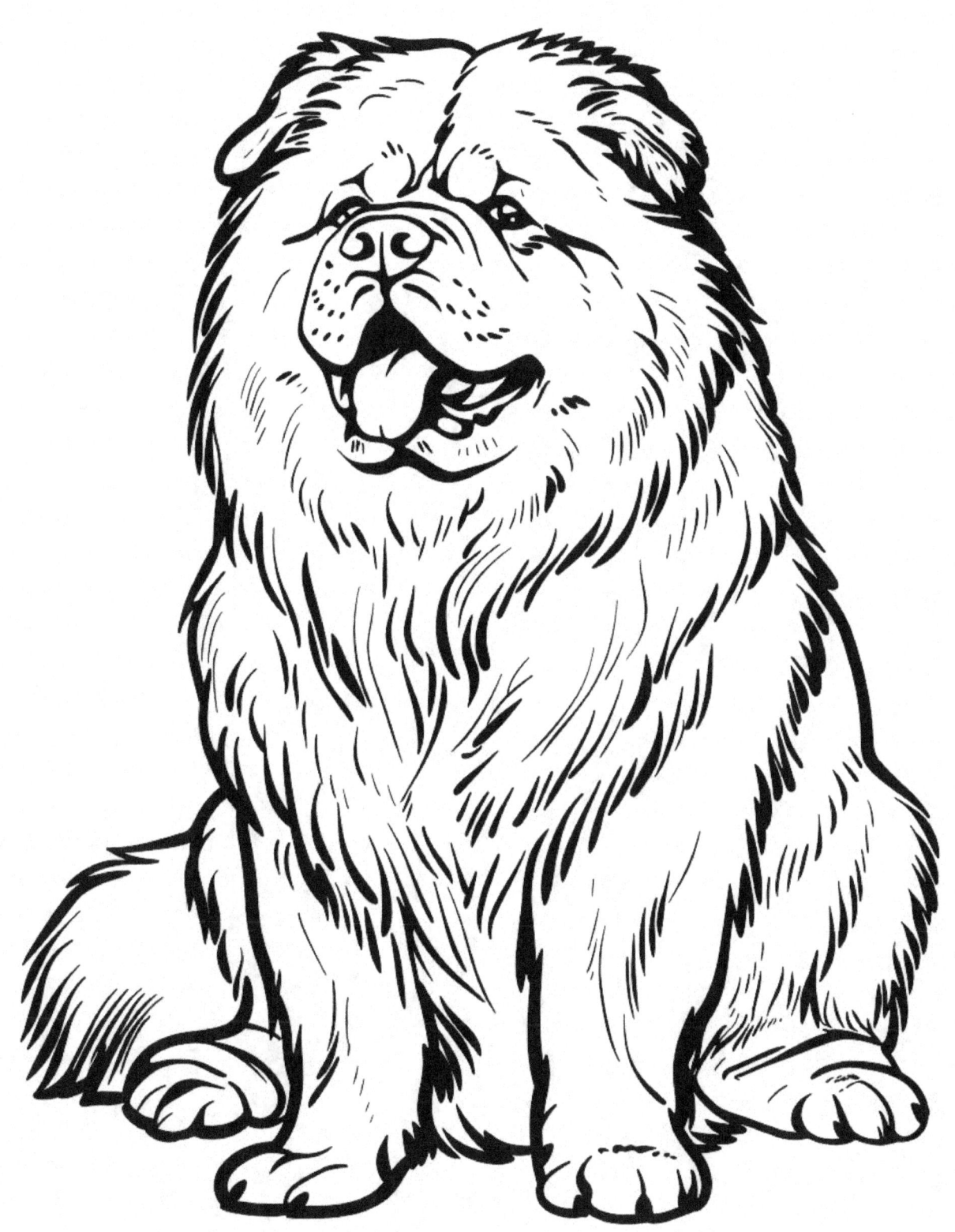

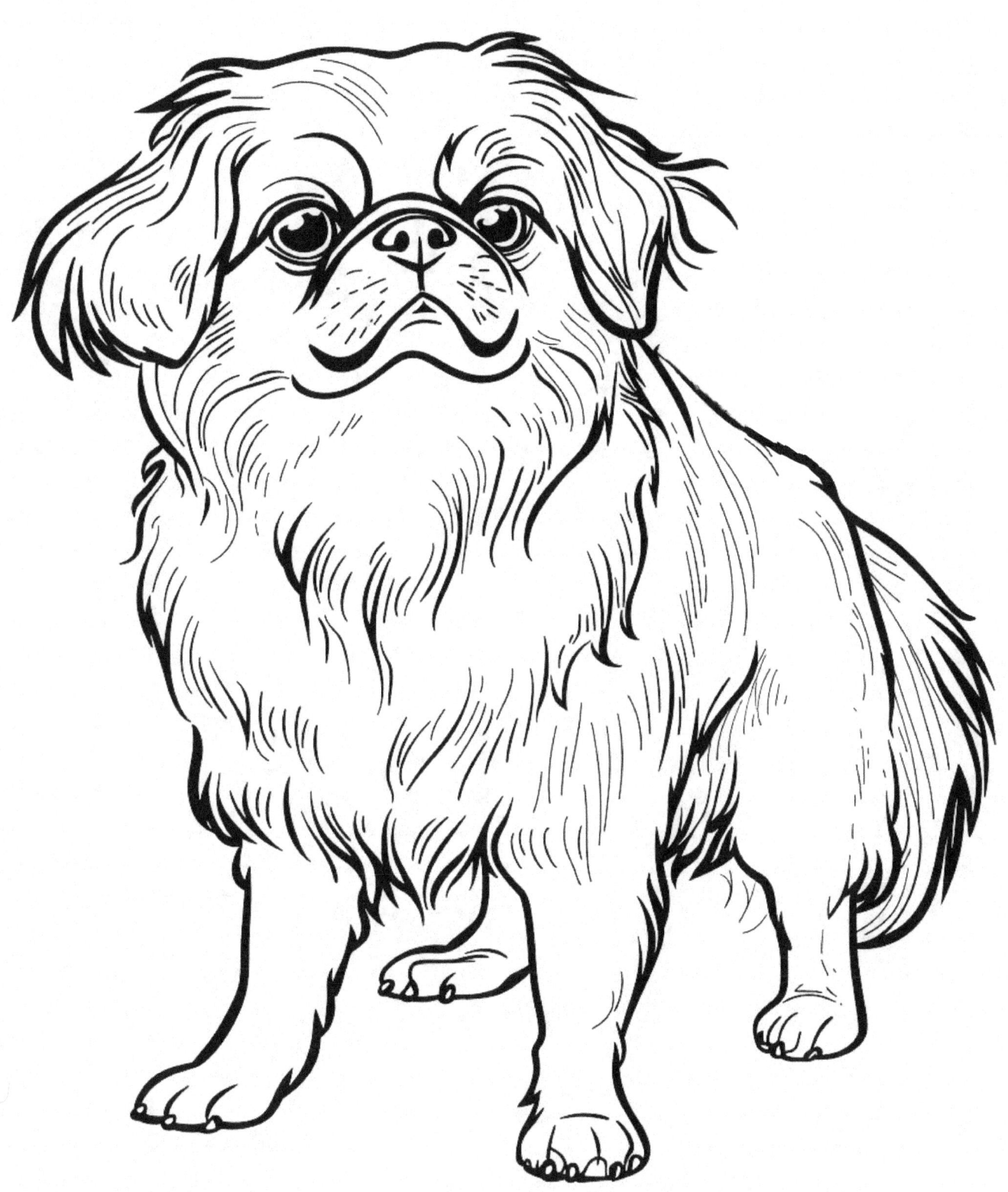

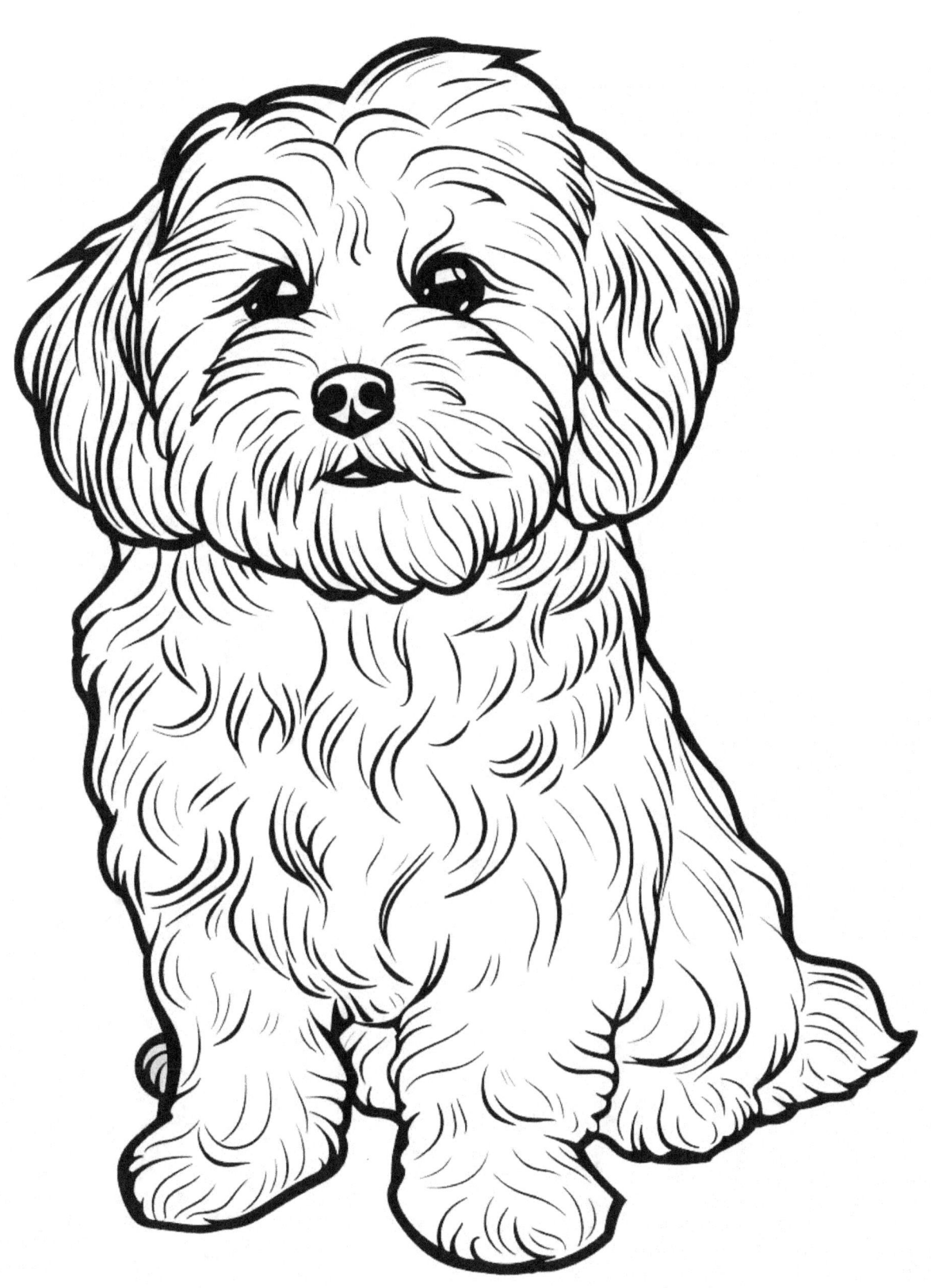

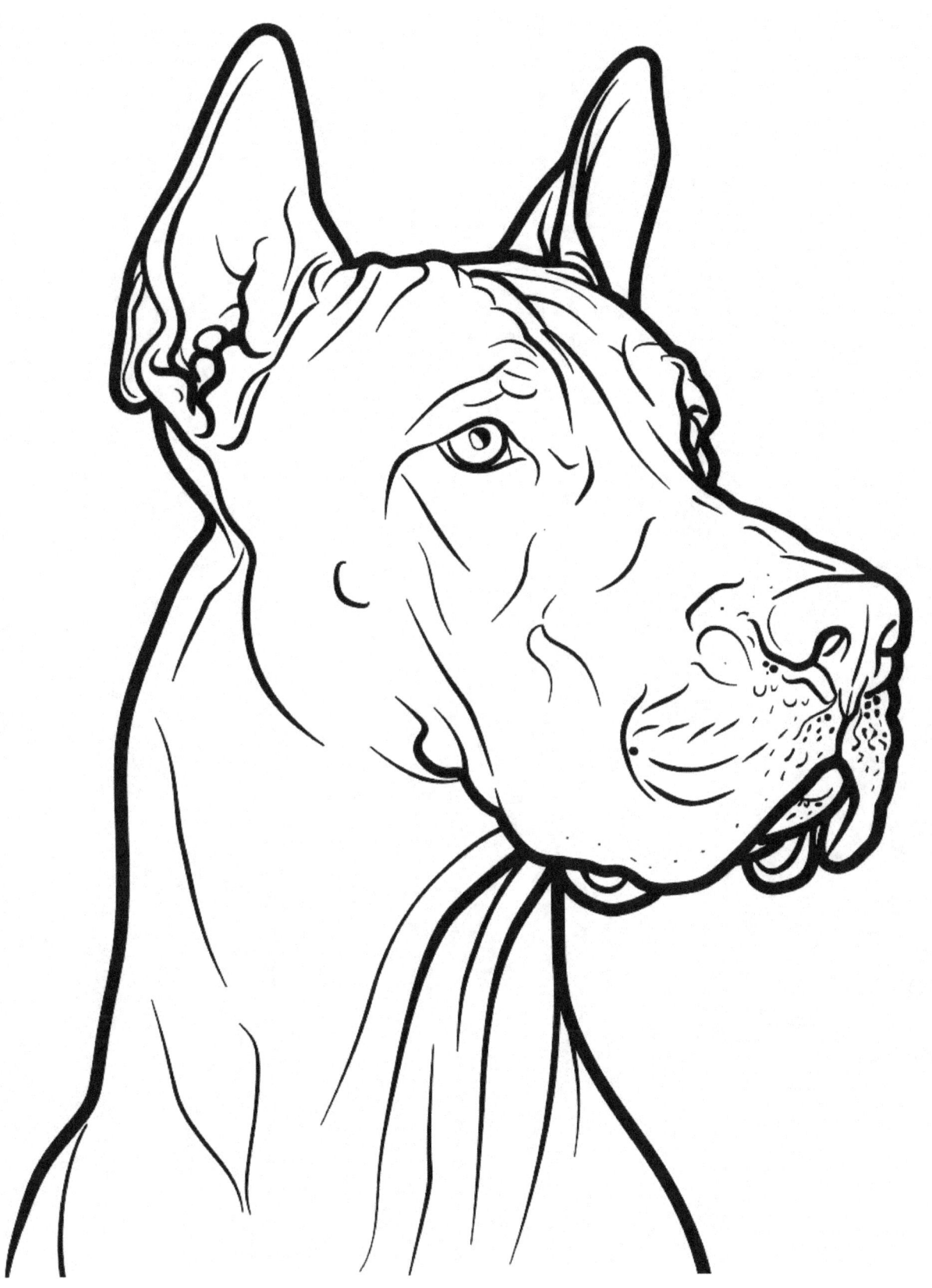

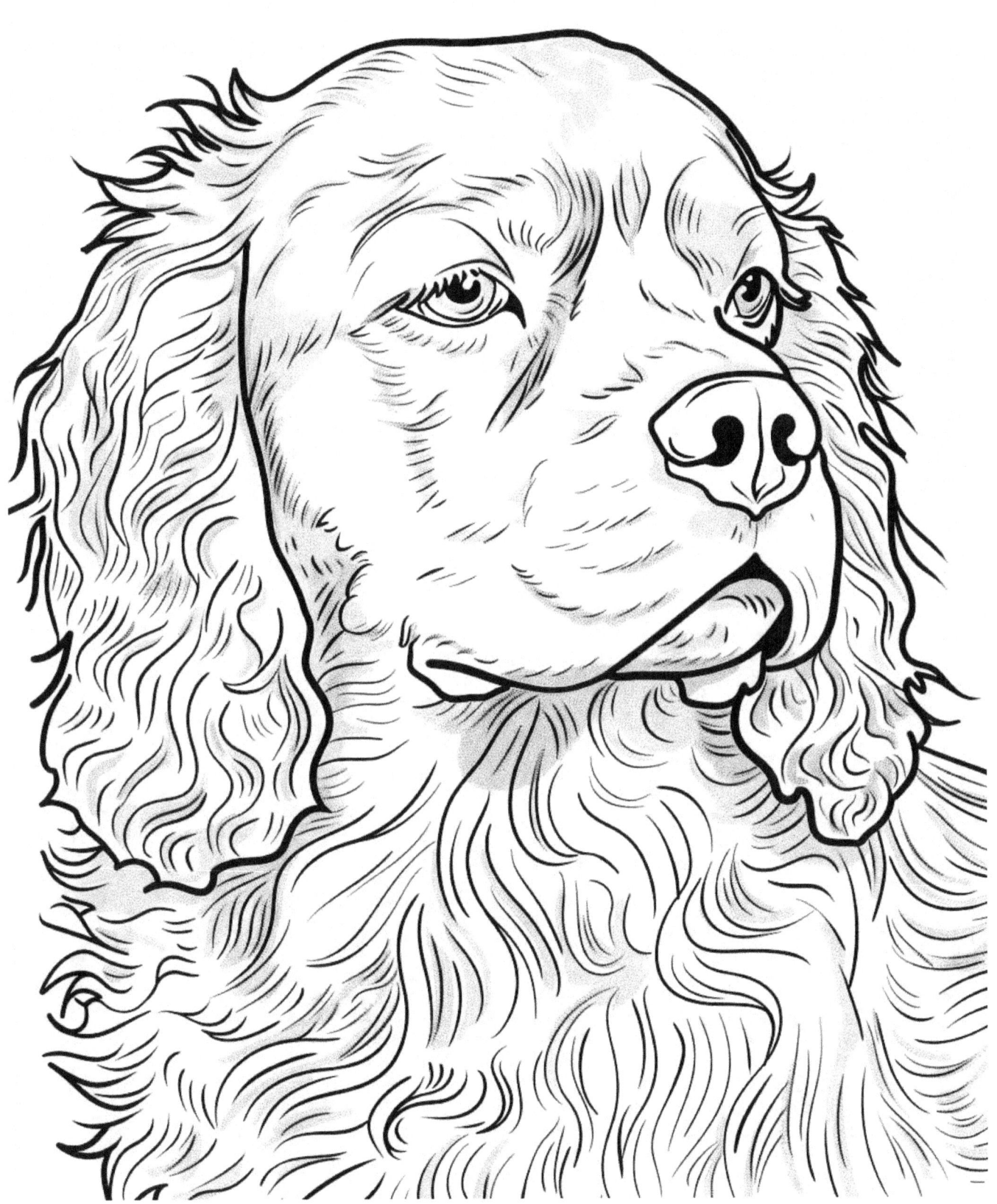

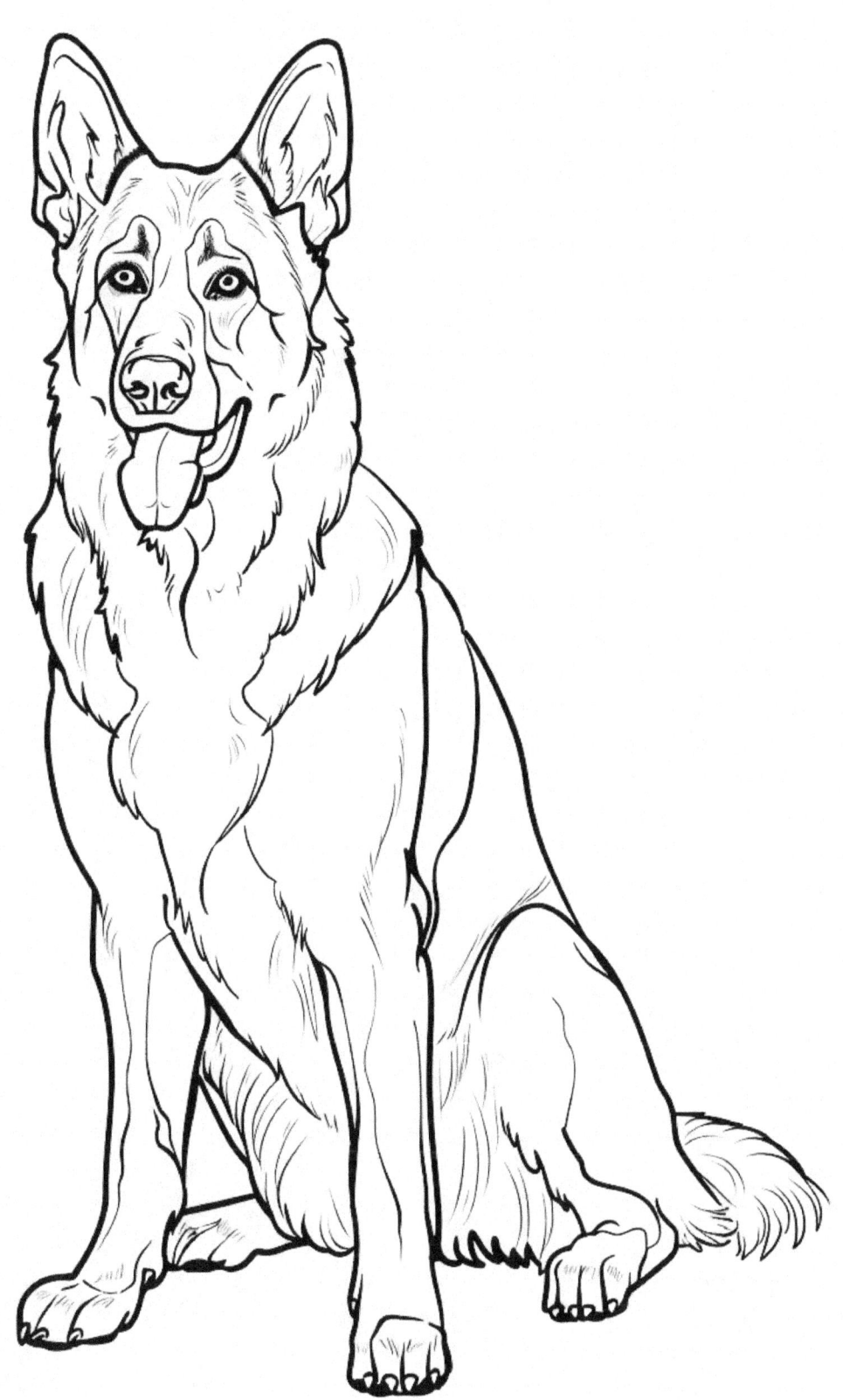

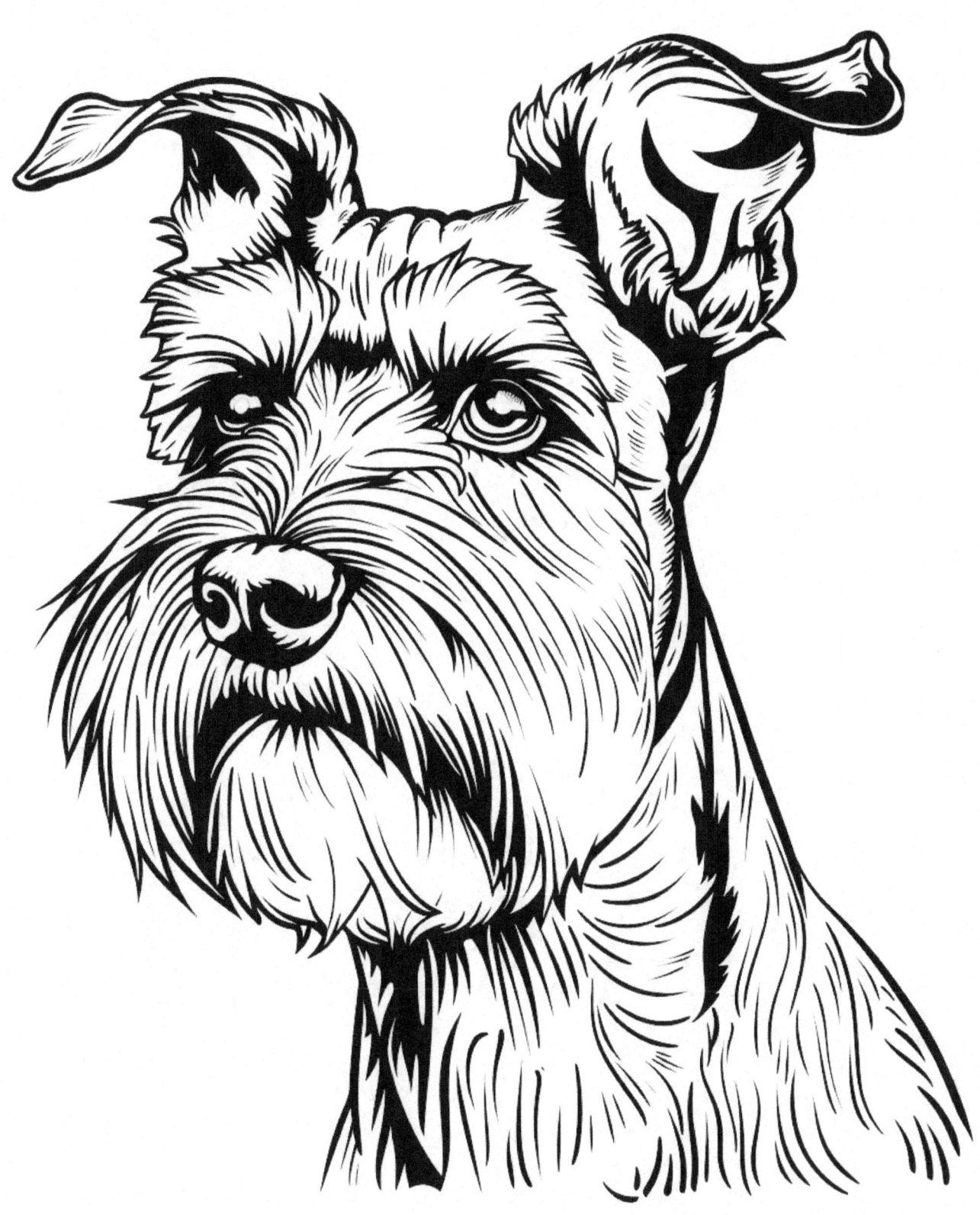

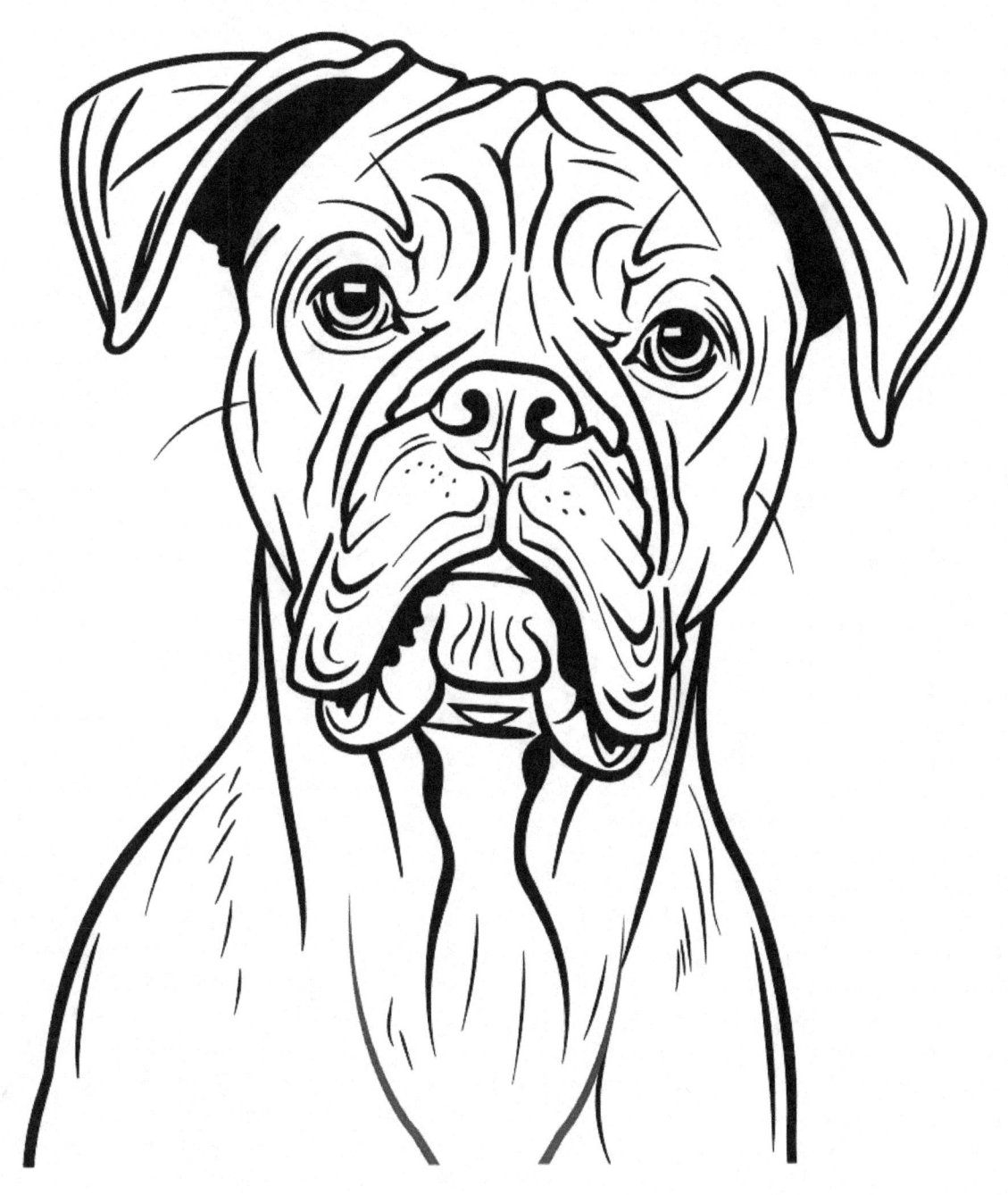

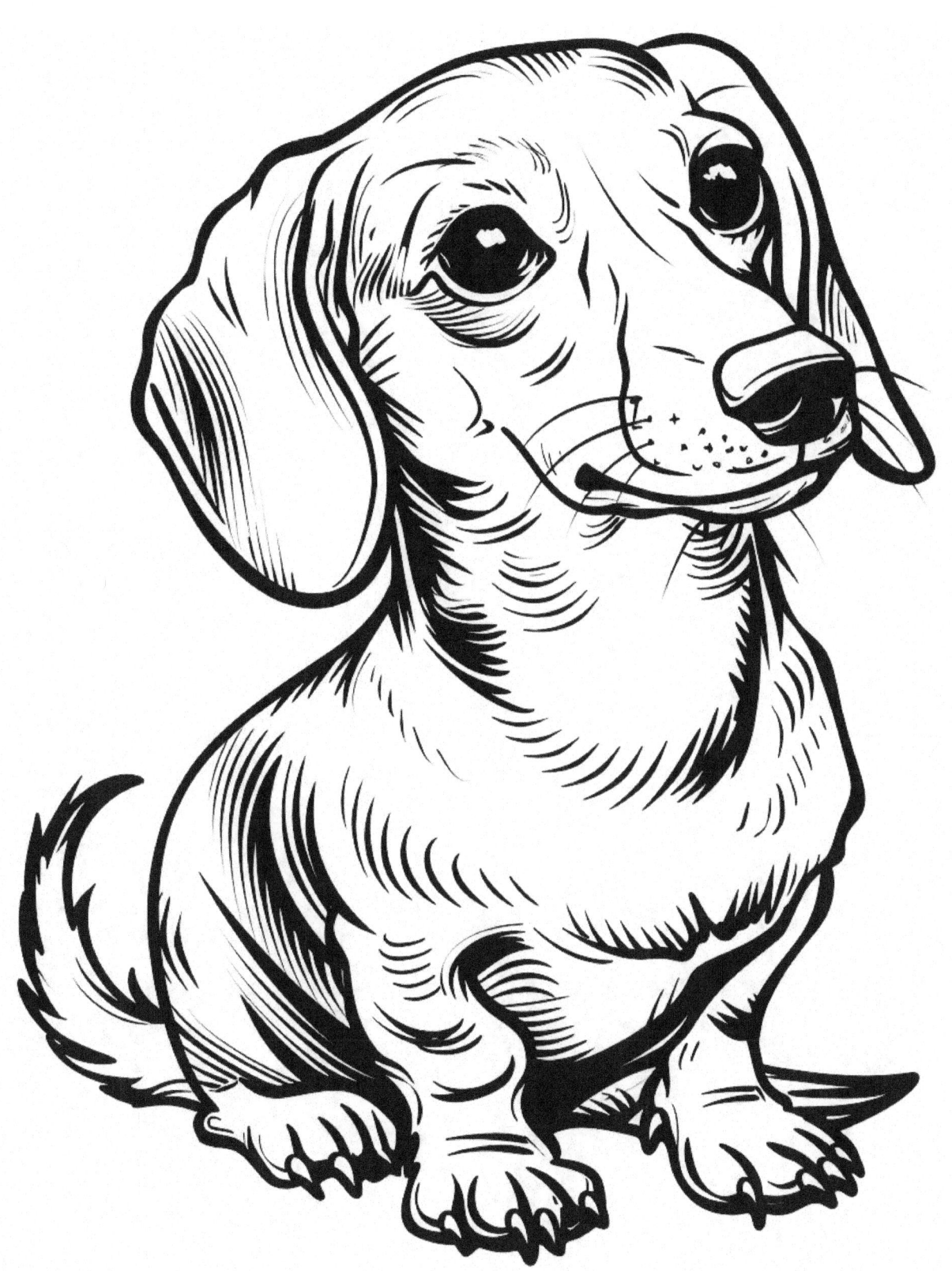

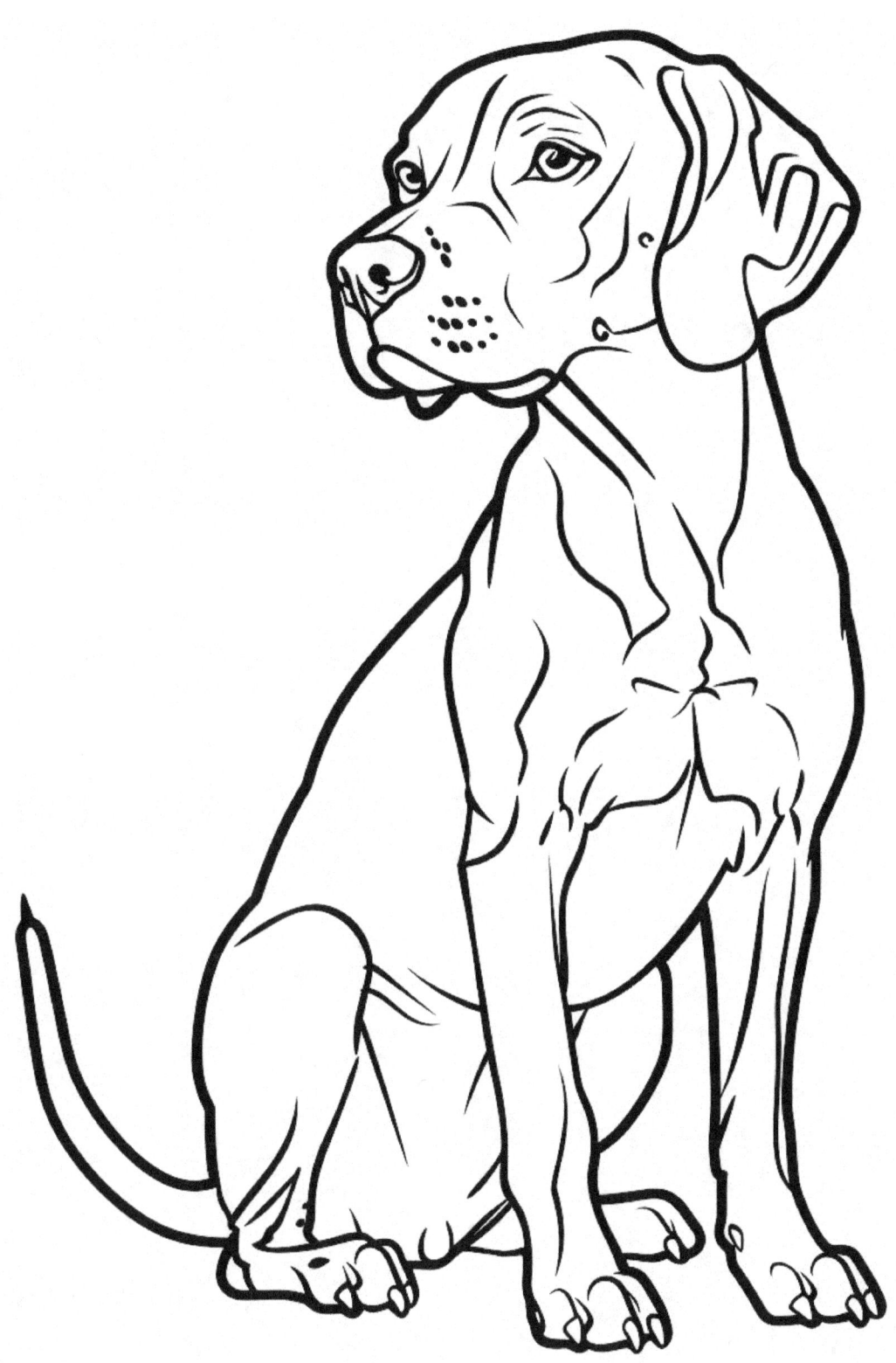

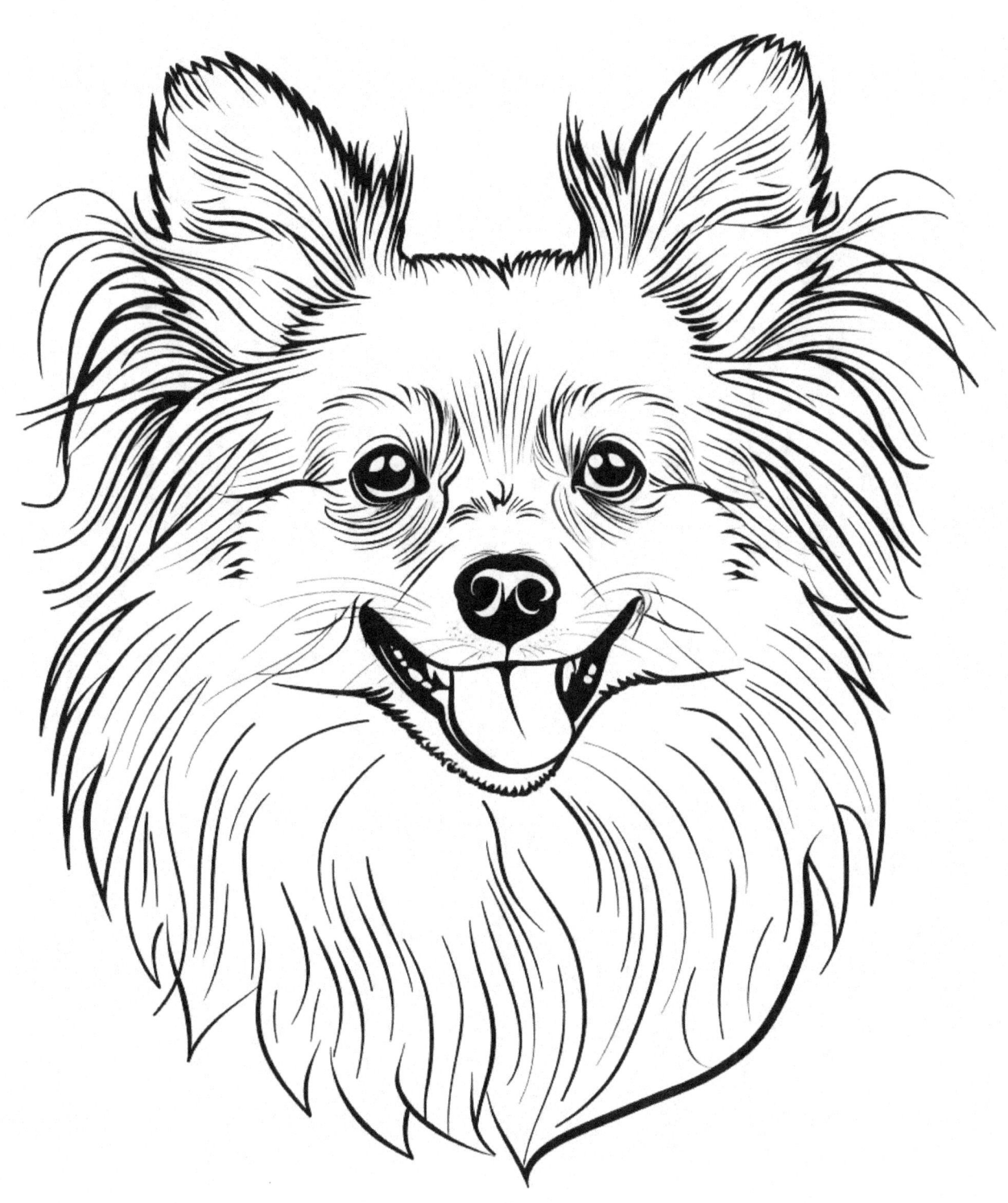

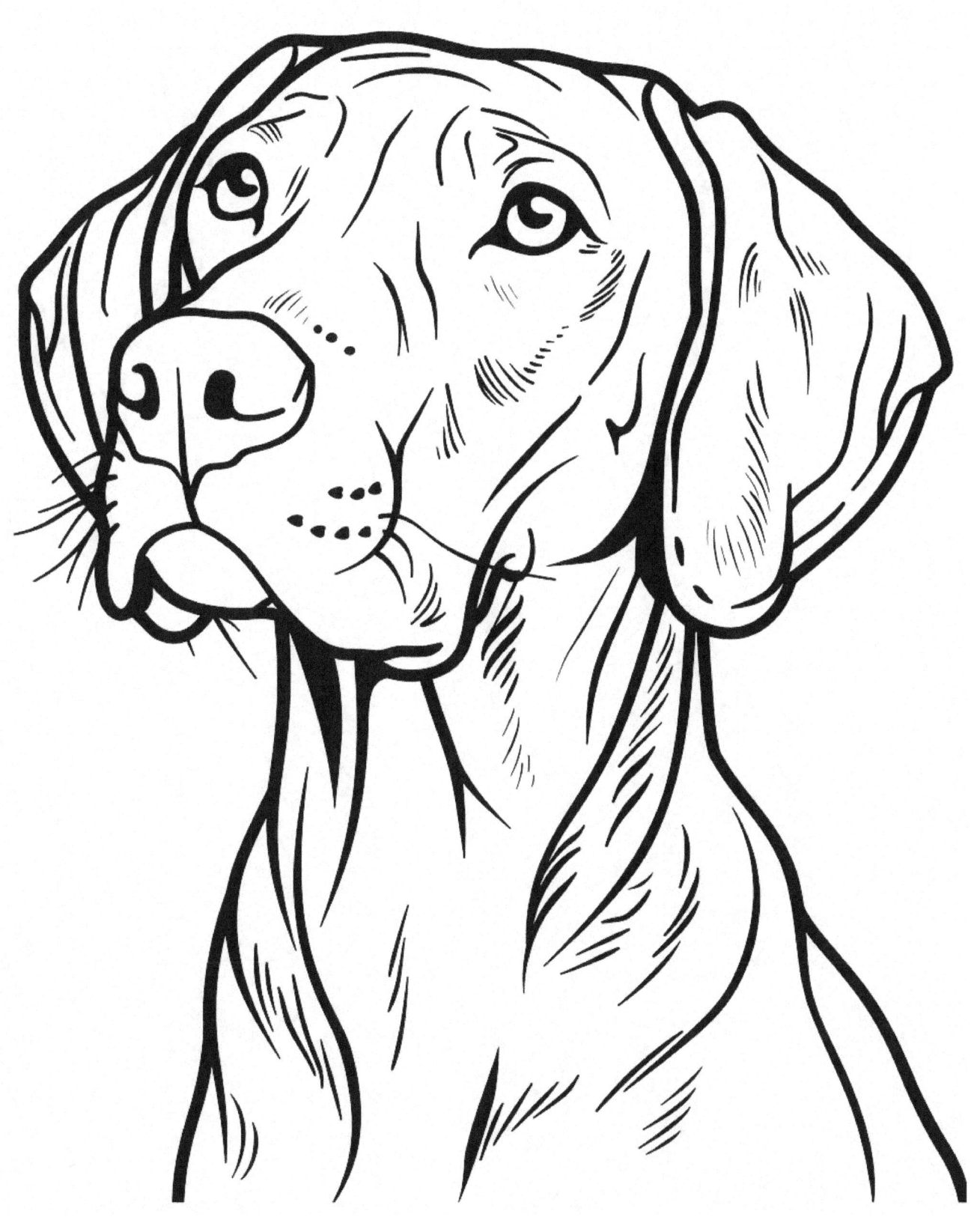

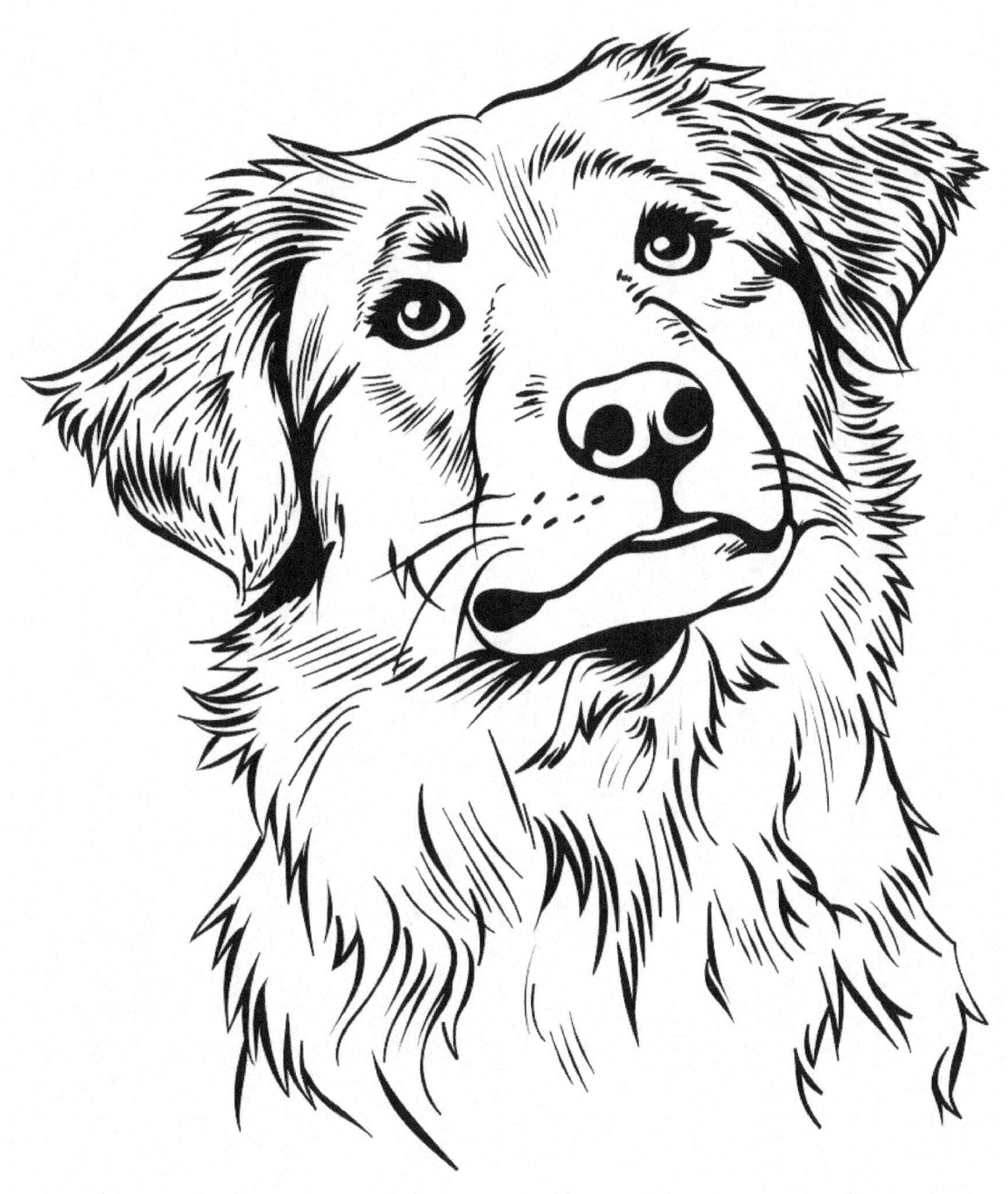

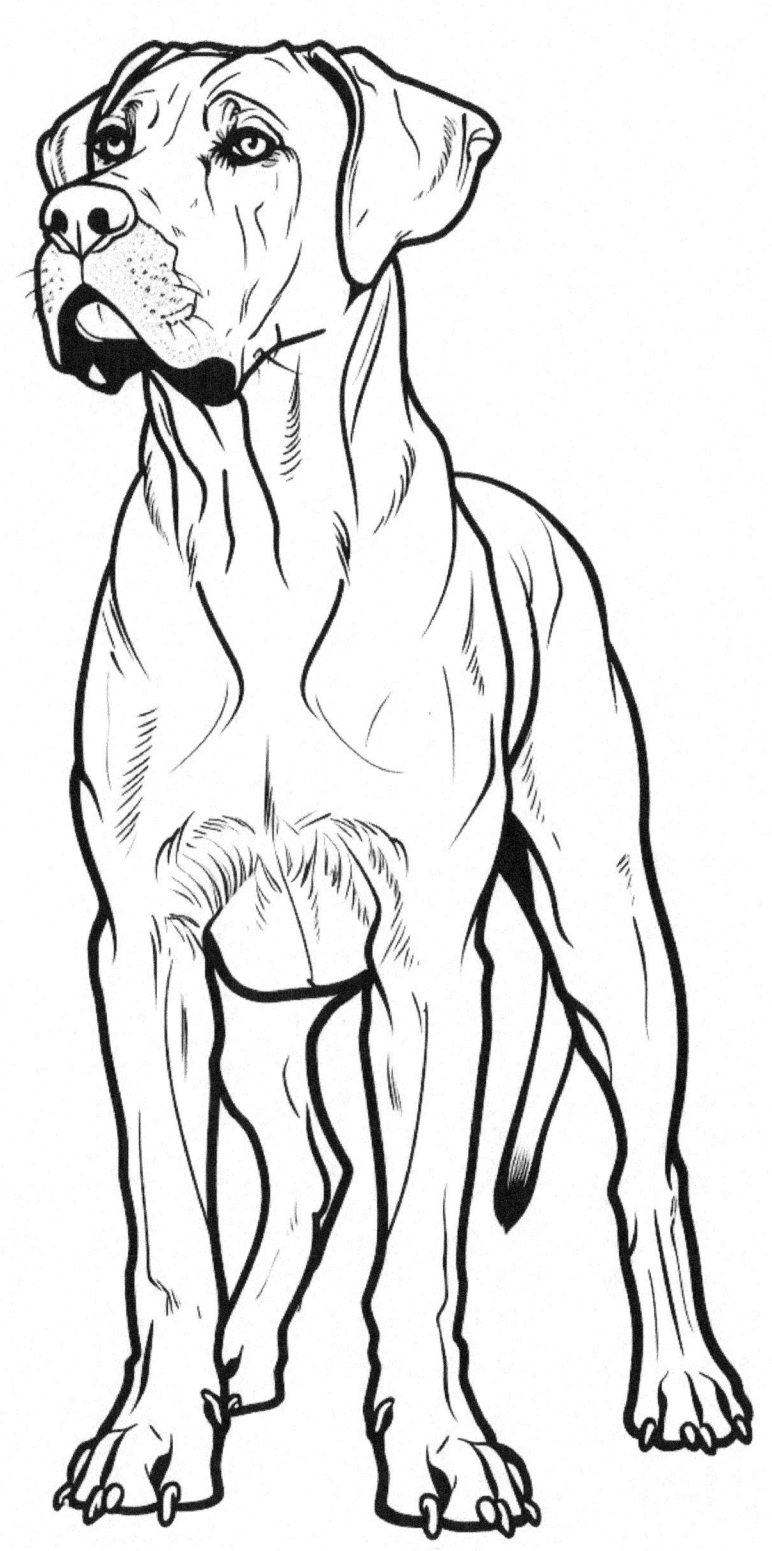

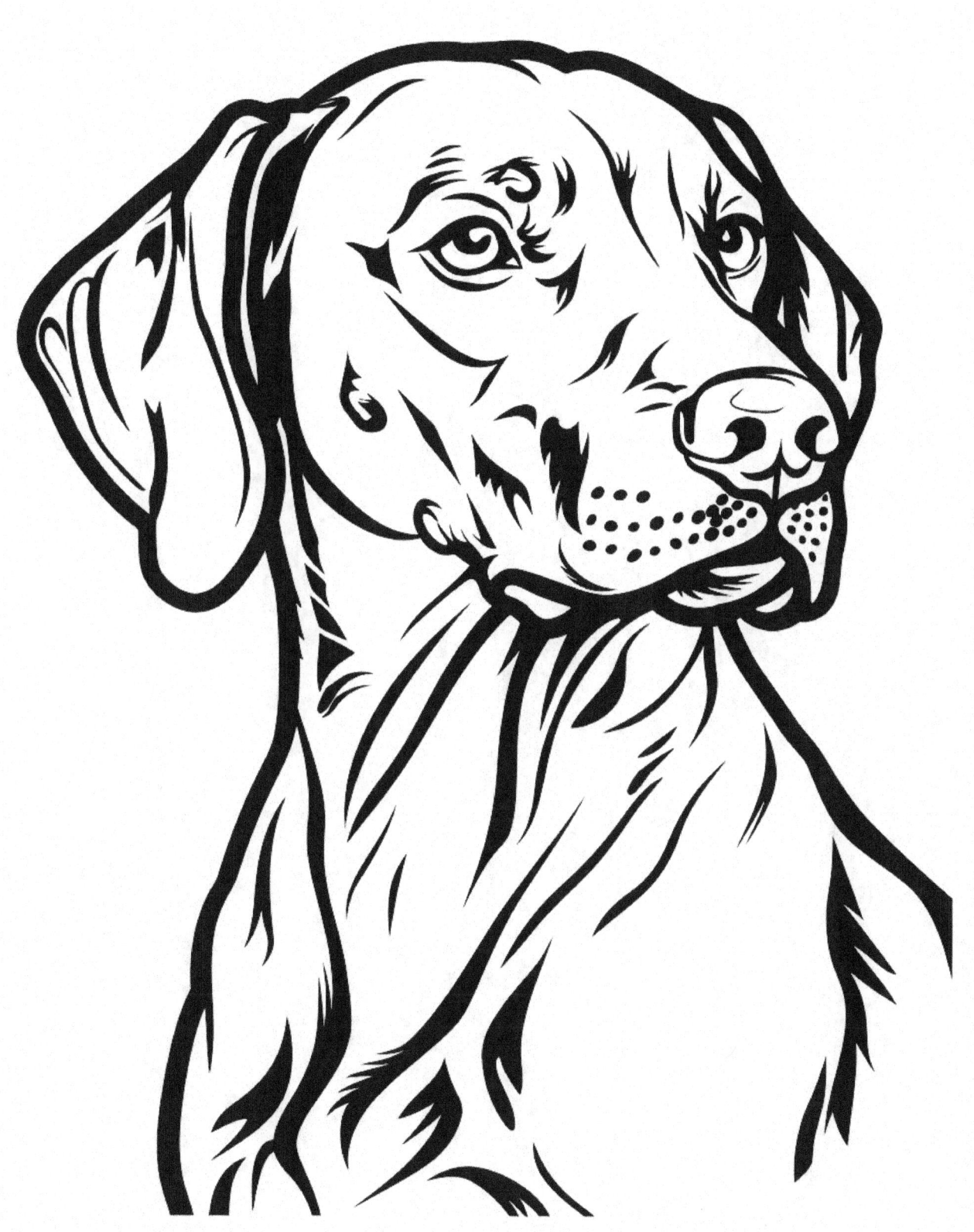

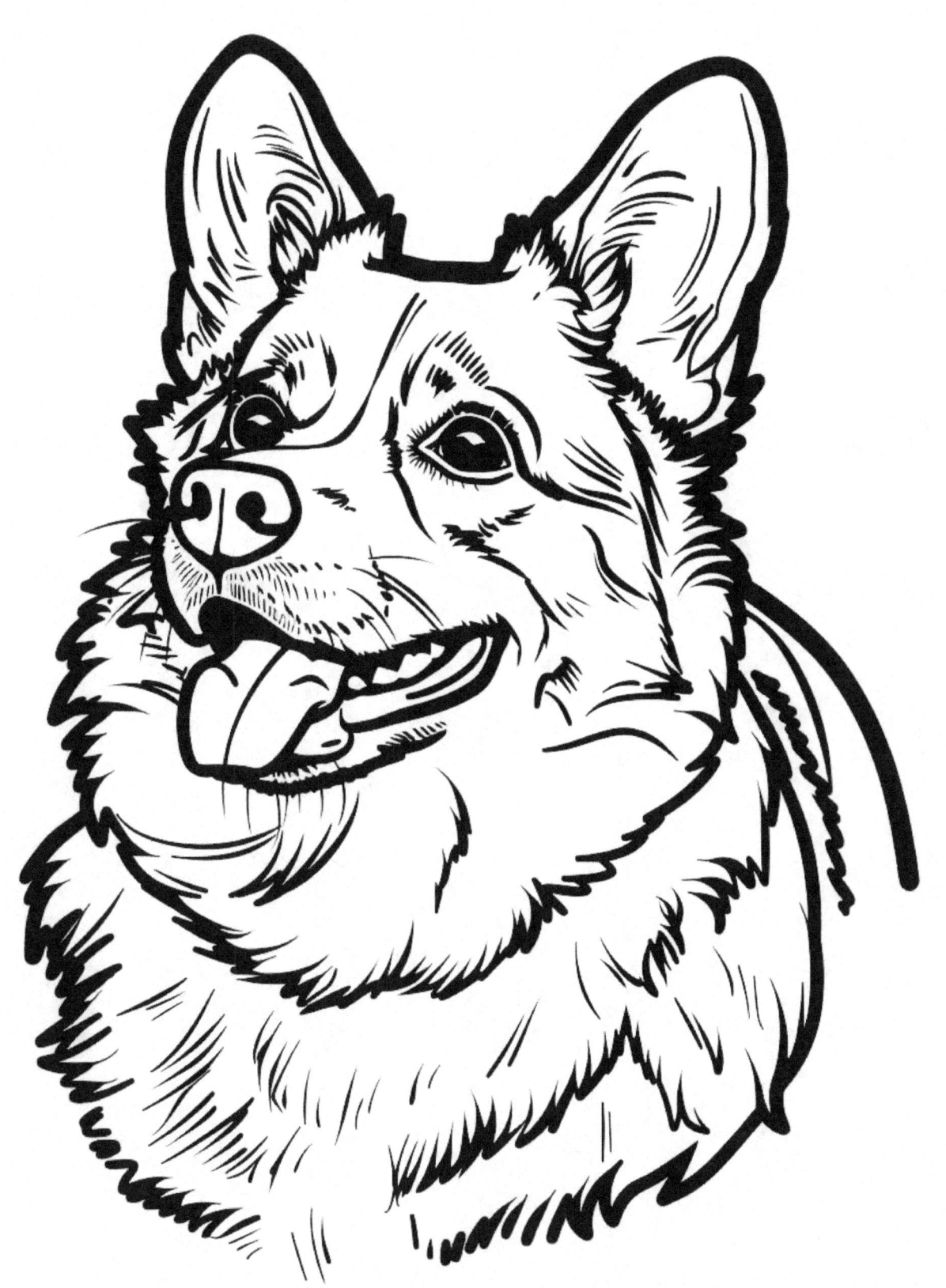

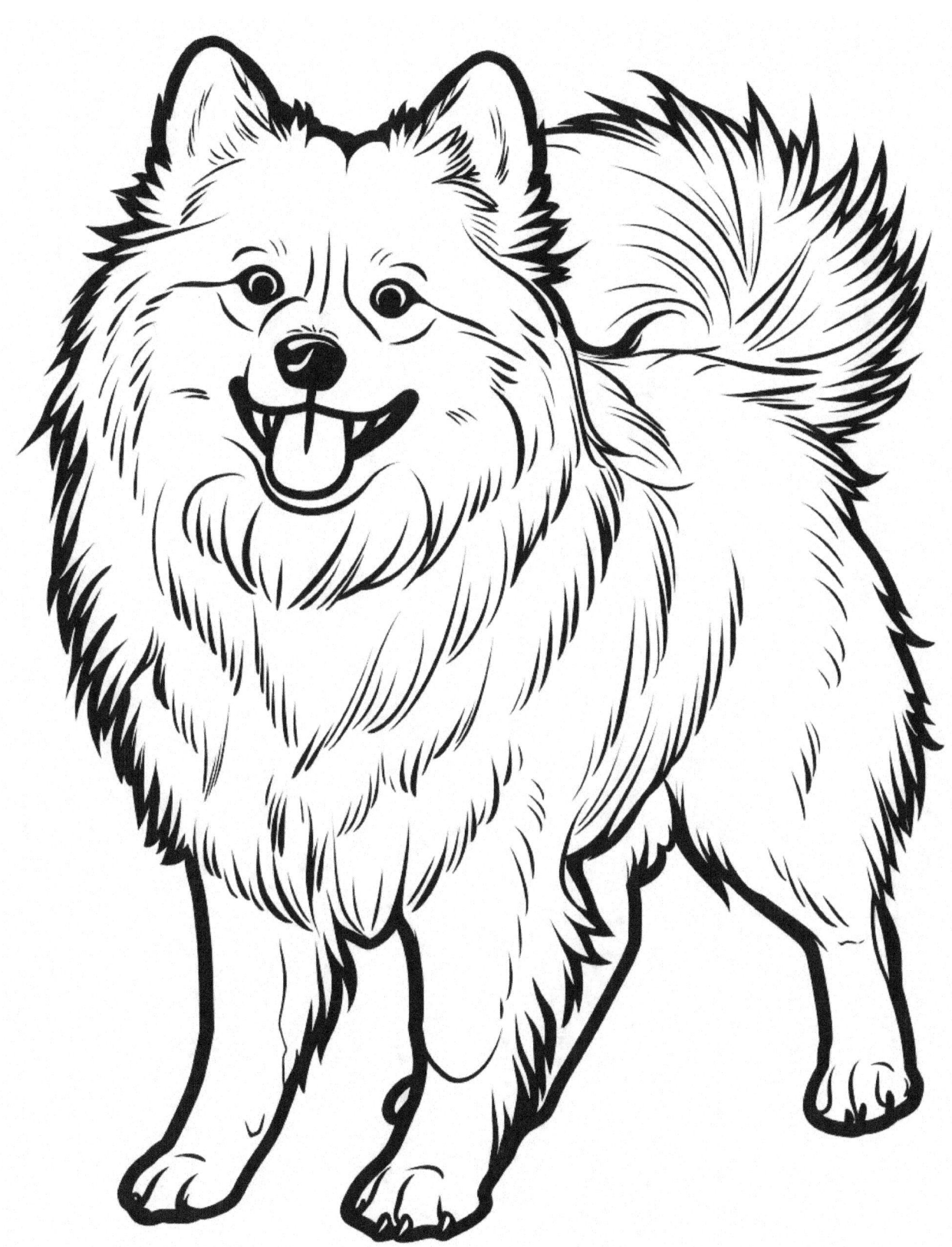

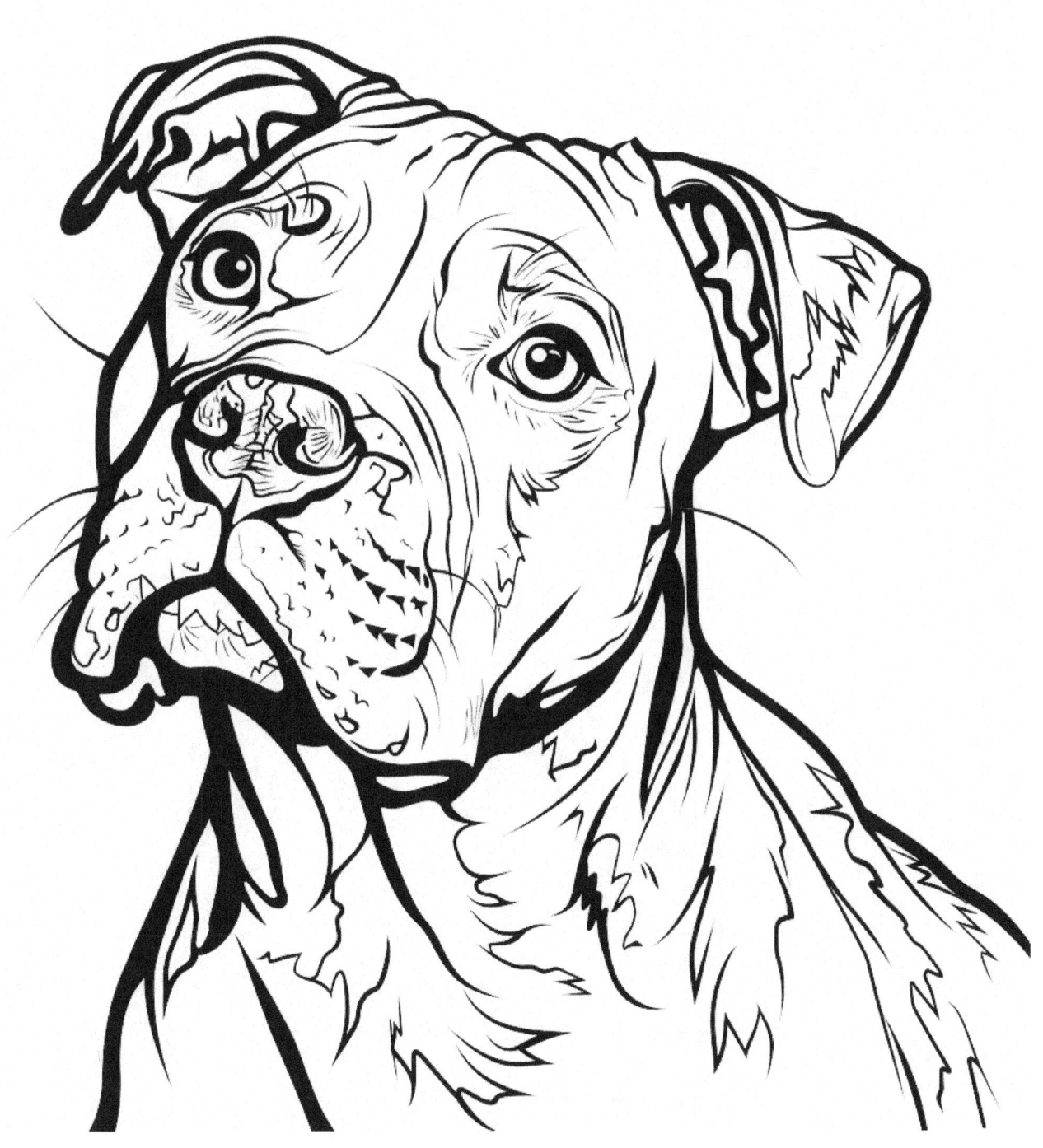

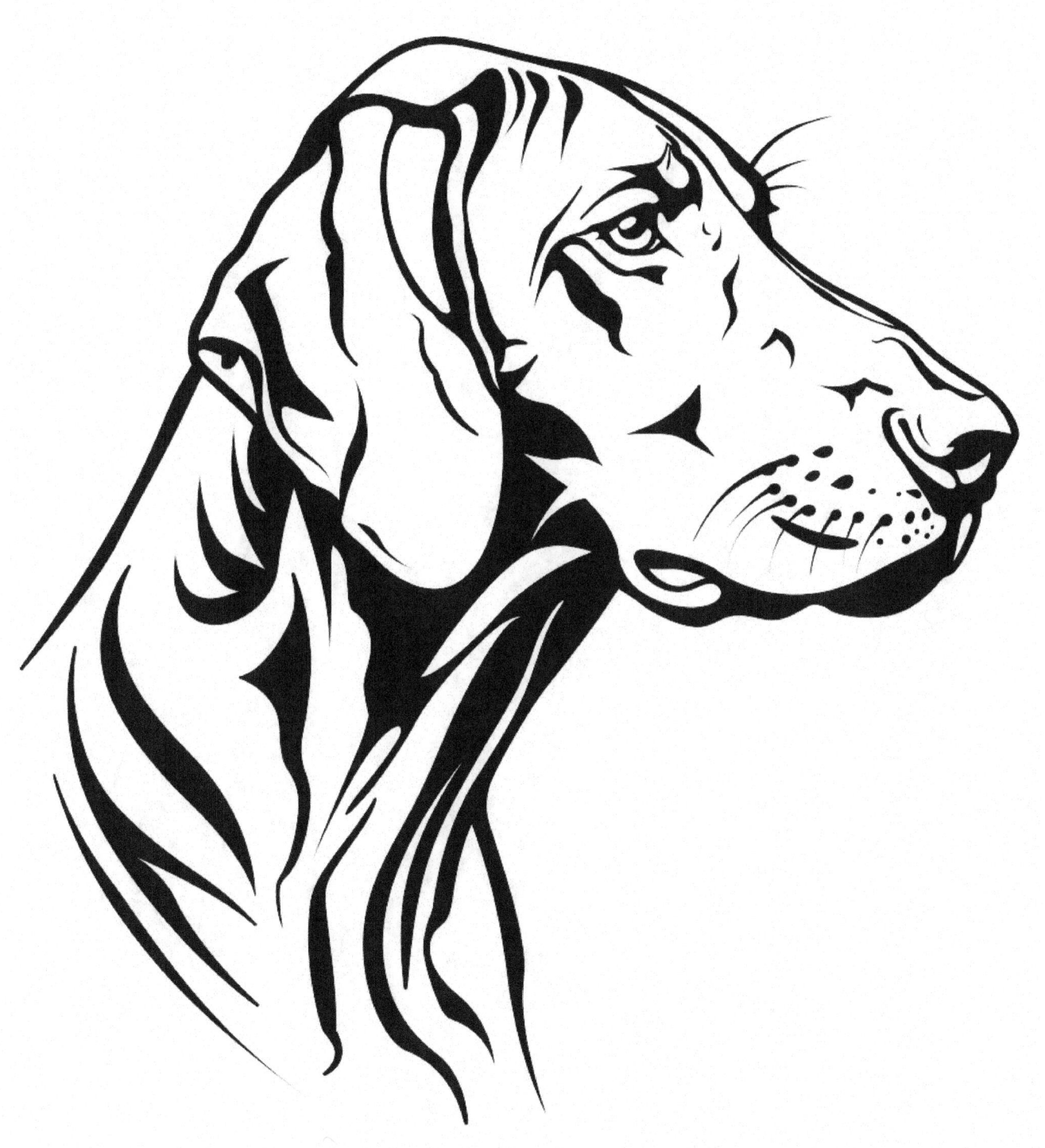

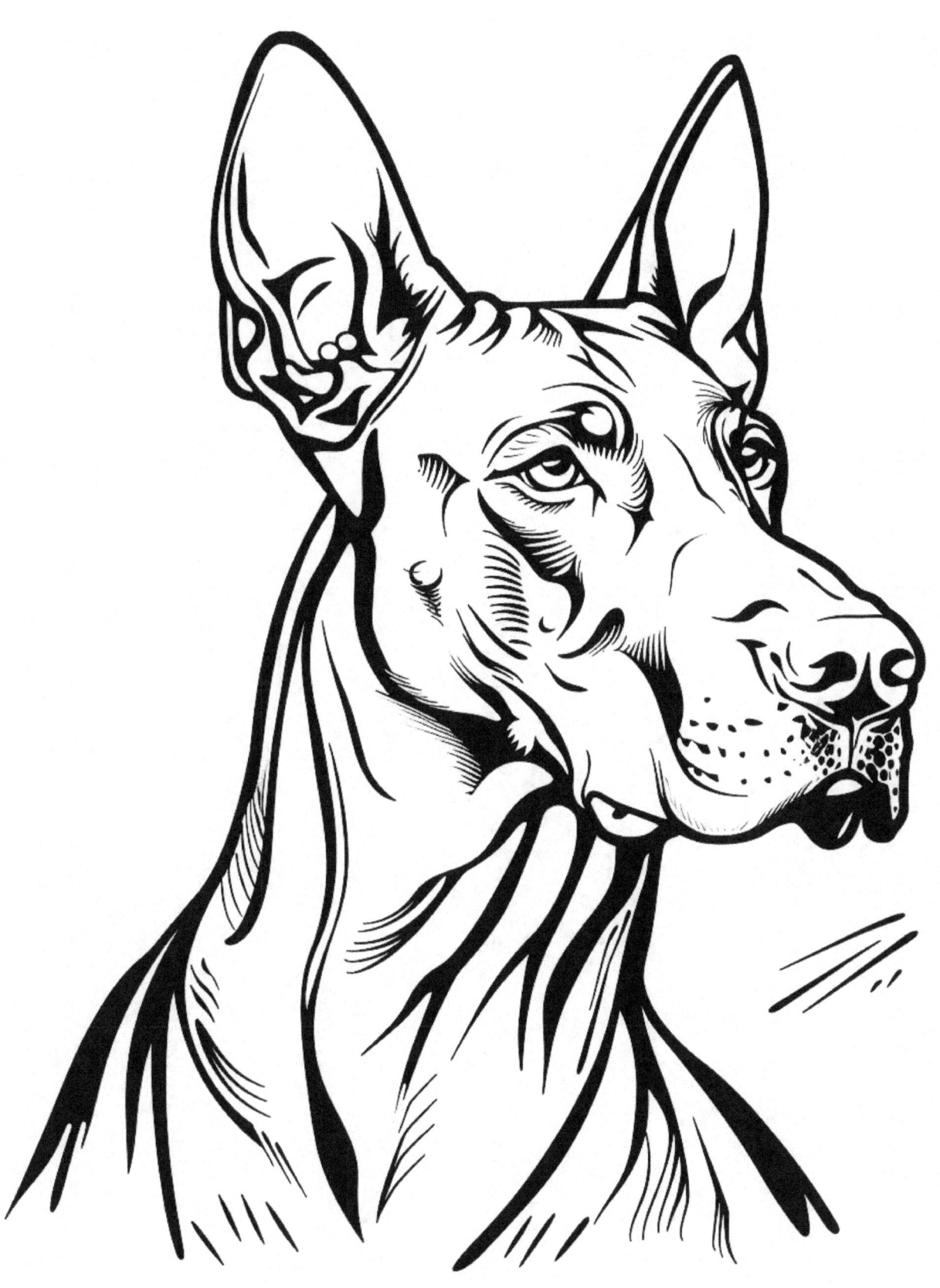

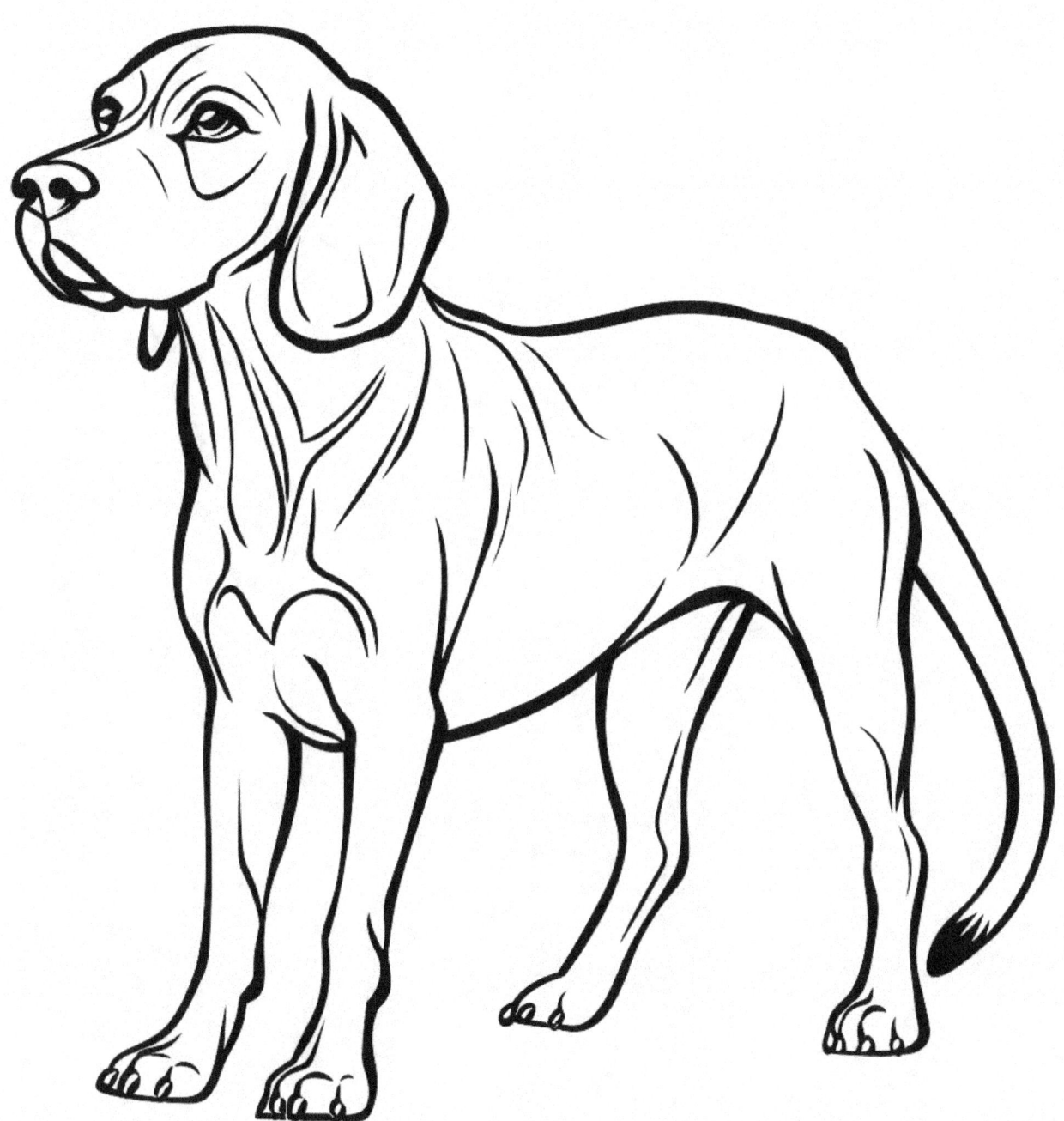

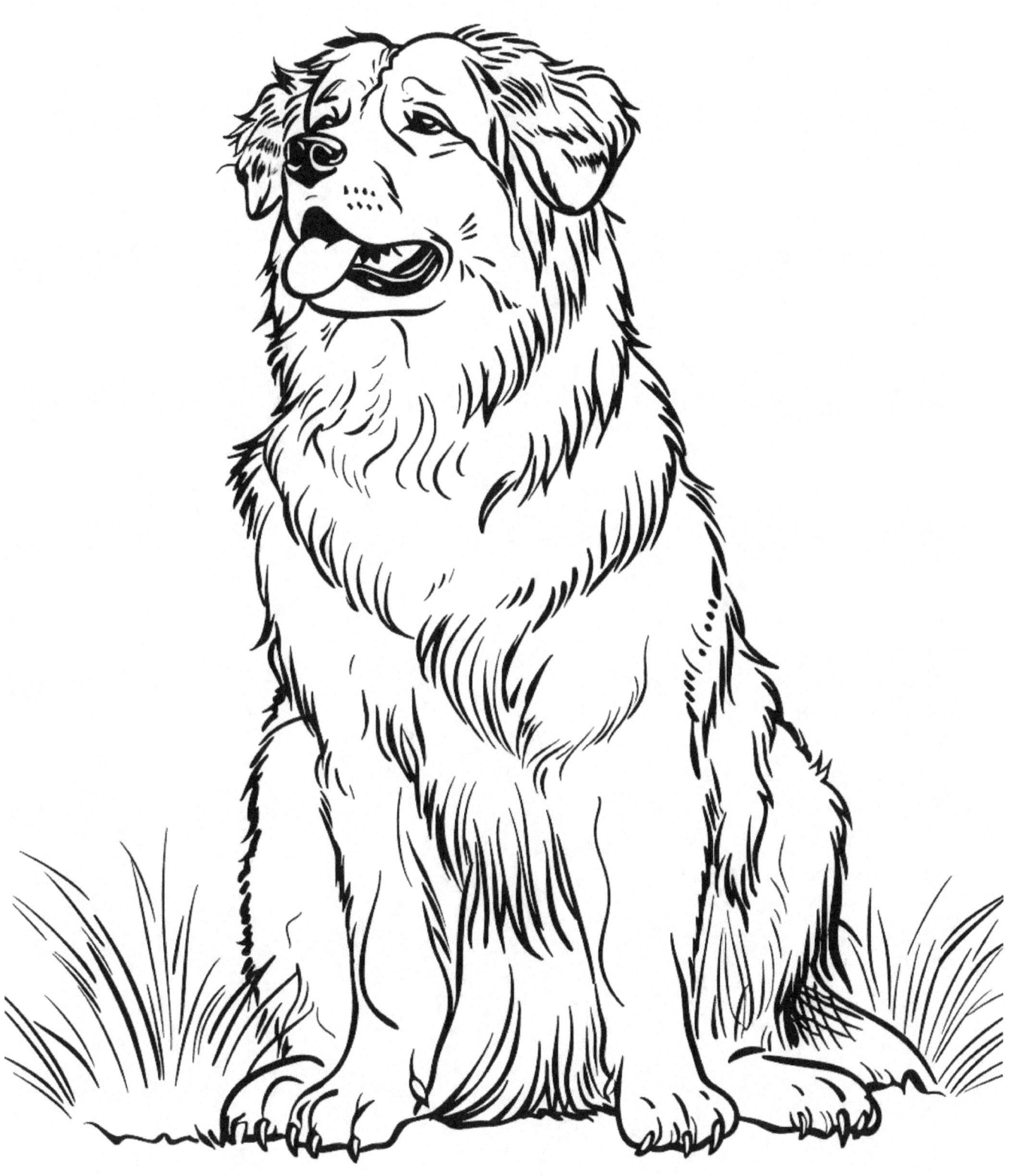

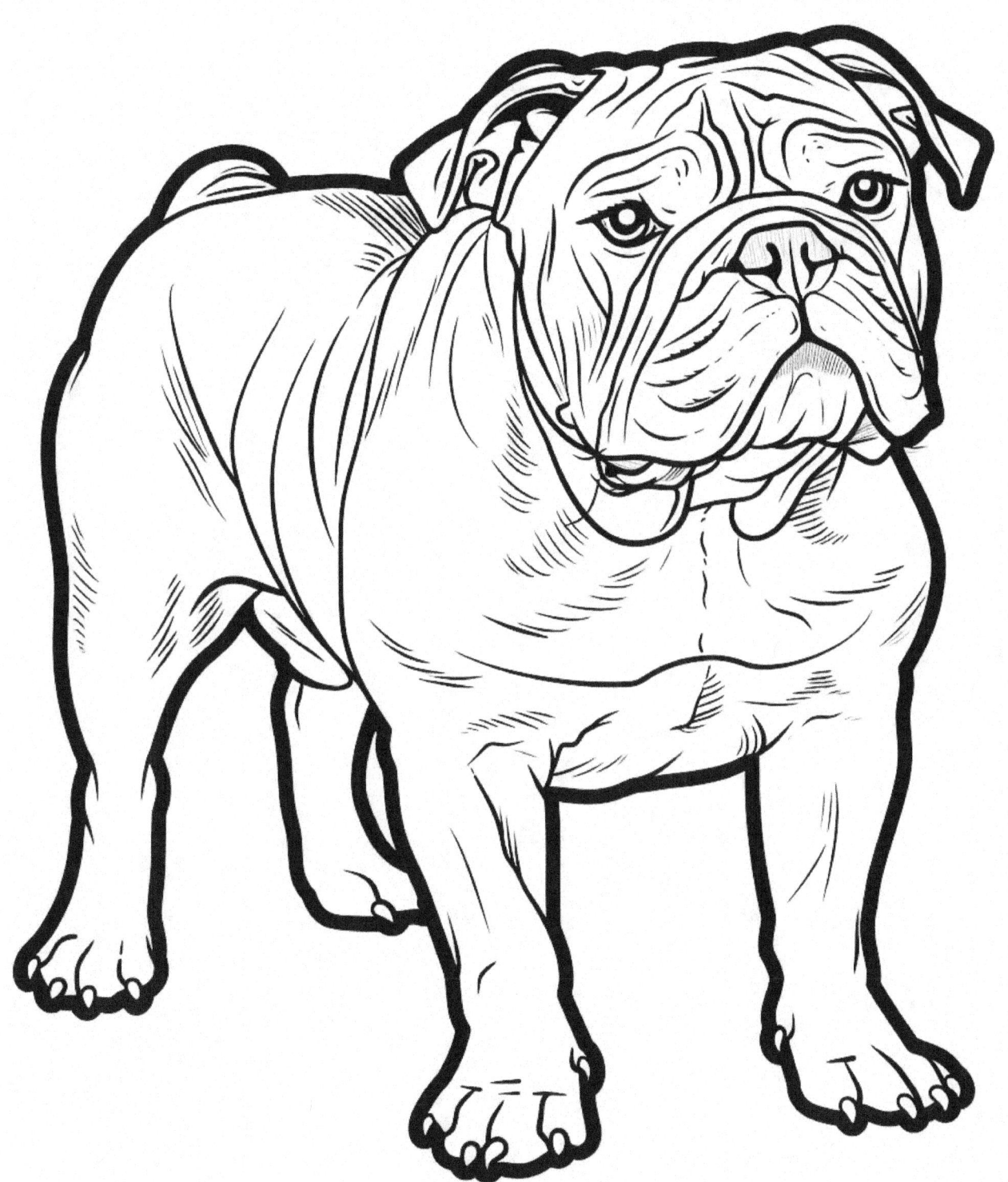

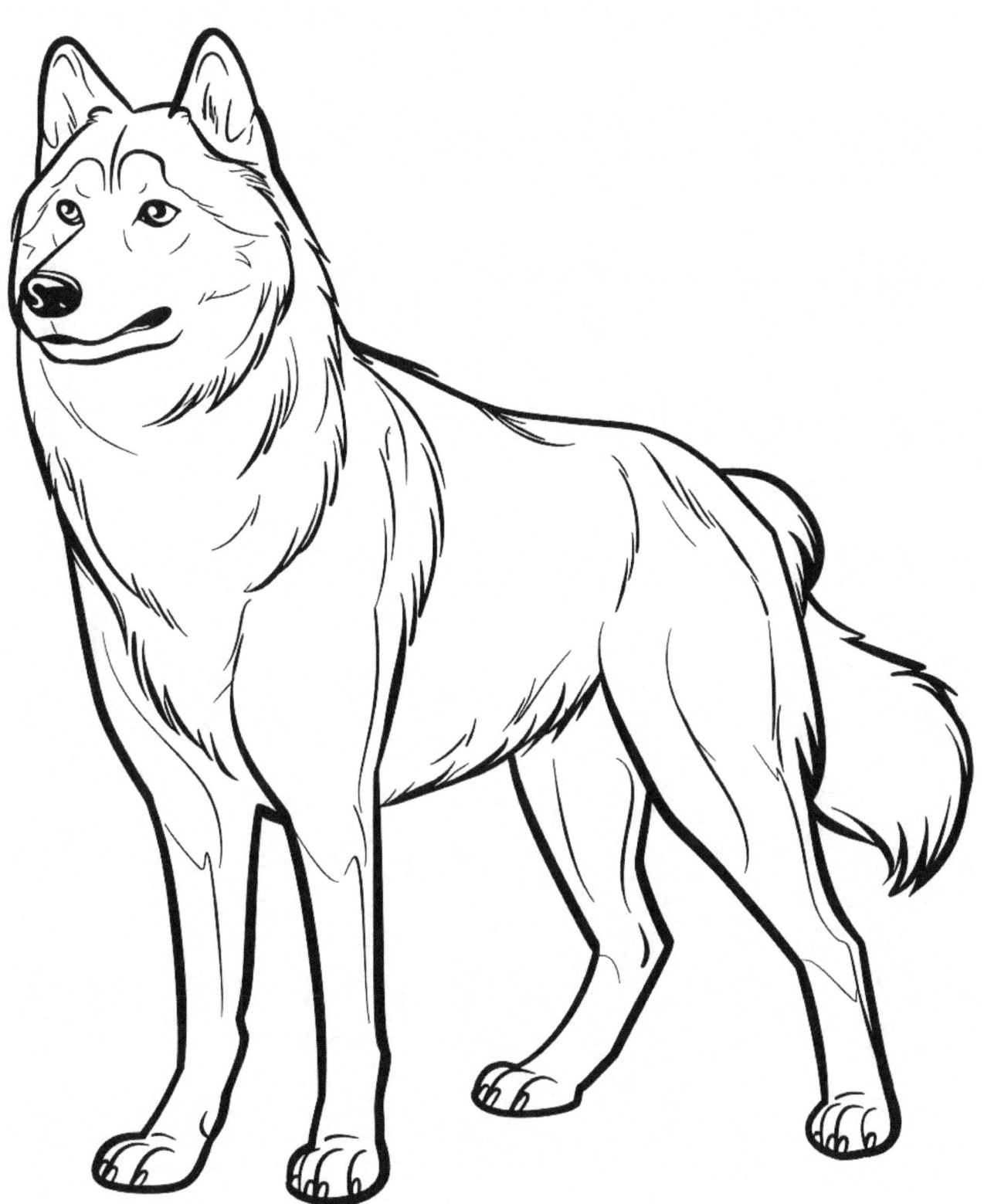

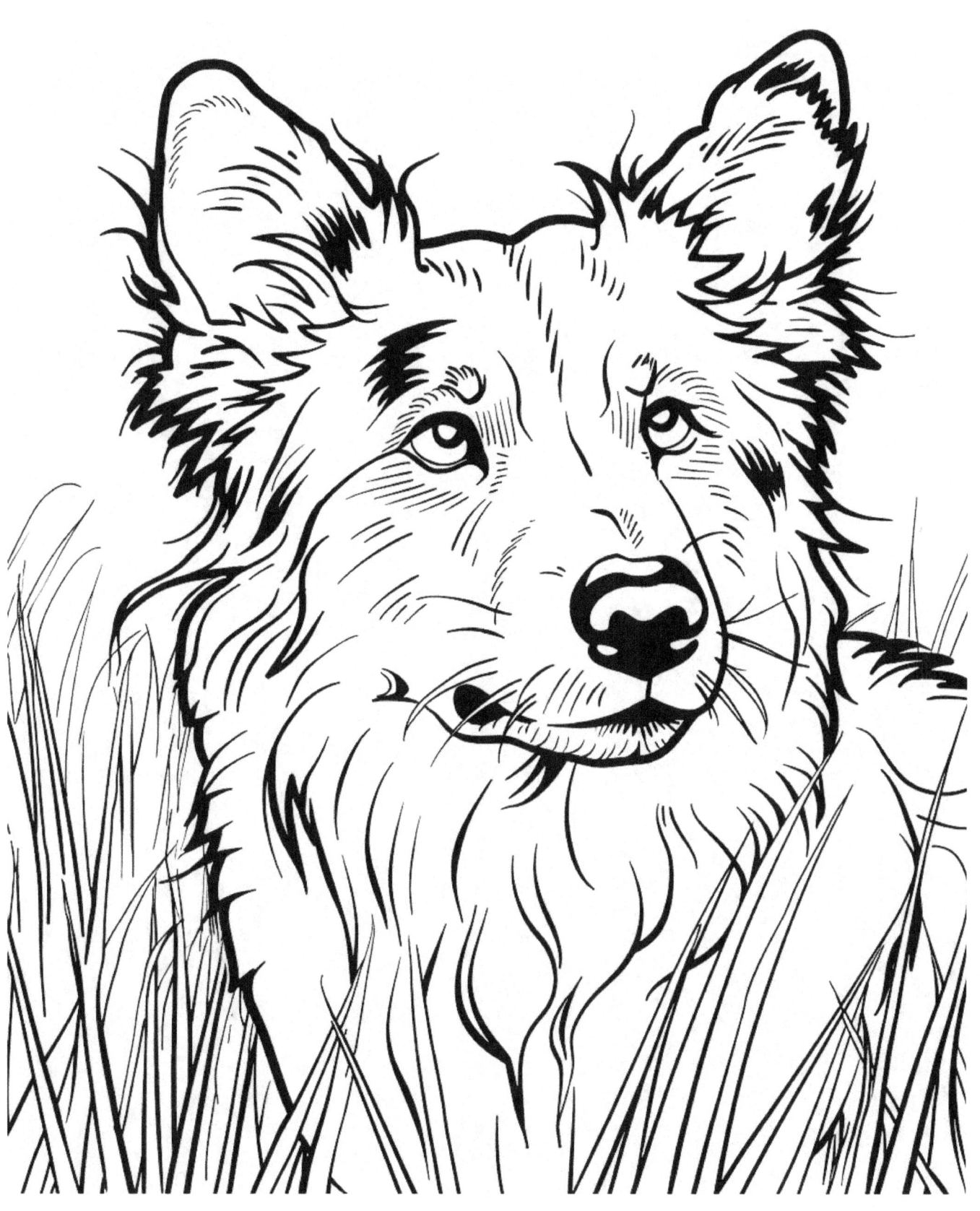

WE HOPE THAT THIS BOOK HAS BECOME NOT ONLY A SOURCE OF CREATIVE INSPIRATION FOR YOU BUT ALSO AN OPPORTUNITY TO DEEPEN YOUR KNOWLEDGE OF THE DIVERSITY OF THE ANIMAL WORLD. MAY EACH COLORED IMAGE BECOME YOUR OWN WORK OF ART, REFLECTING YOUR LOVE FOR NATURE AND ANIMALS. KEEP DRAWING, CREATING, AND ENJOYING THIS FASCINATING PROCESS!

www.ingramcontent.com/pod-product-compliance
Lightning Source LLC
Chambersburg PA
CBHW080435240526
45479CB00015B/1164